IMAGES
of America

ADIRONDACK VENTURES

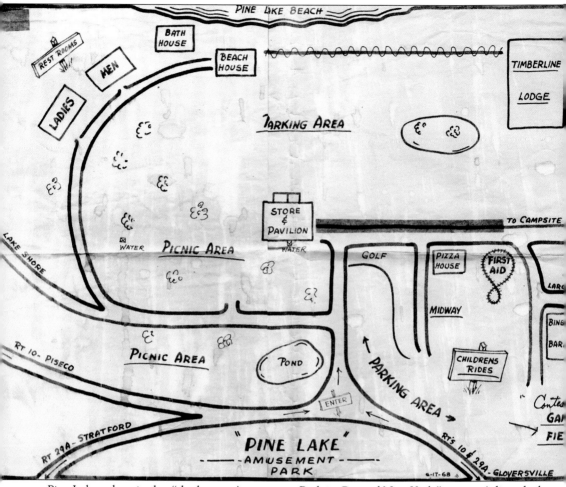

Pine Lake, advertised as "the largest Amusement Park in Central New York," was an Adirondack amusement park of the 20th century. Its central midway, with games of chance and rides, was surrounded by other attractions: dance halls, ball fields, arcades, animals, and picnic areas. Employees and organizations that came to the park used hand-drawn maps like this one to set up competitions and games for annual picnics and outings.

On the cover: Those who ventured into the Adirondacks in the early 20th century arrived via the new horseless carriage, the automobile. Earlier, thousands had traveled into the region via guide boats, horses, oxen, steamers, and railroads, but it was the automobile that heralded the Adirondacks' heyday. Families and friends loaded up big touring cars and sought any destination they desired. Driving over the unfinished roads was always an adventure—one that sometimes ended up in a mountain stream, and then the local farmer had to bring his horses to pull the newfangled machine out of the water. (Courtesy of author's collection.)

IMAGES
of America
ADIRONDACK VENTURES

Donald R. Williams

Copyright © 2006 by Donald R. Williams
ISBN 978-0-7385-4560-8

Published by Arcadia Publishing
Charleston, South Carolina

Printed in the United States of America

Library of Congress Catalog Card Number: 2006926322

For all general information contact Arcadia Publishing at:
Telephone 843-853-2070
Fax 843-853-0044
E-mail sales@arcadiapublishing.com
For customer service and orders:
Toll-Free 1-888-313-2665

Visit us on the Internet at www.arcadiapublishing.com

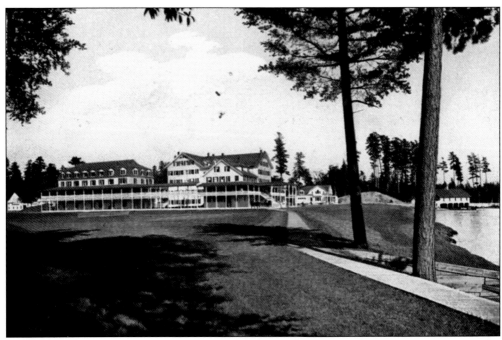

Apollos "Paul" Smith's giant hotel stood on the shores of St. Regis Lake as testimony to one who ventured into the Adirondacks and did it his way. Paul Smith, who started as an Adirondack guide, built a sporting house in 1848 at age 23, a hunters' lodge on the Saranac River in 1851, and a 100-room hotel on St. Regis Lake a decade later. Over the years, he and his wife Lydia were involved in real estate, an electric company, a railroad, a store, a 60-horse stable, a four-story warehouse, a laundry, a casino, game rooms, and a post office. After Smith died in 1912 at age 87, his son Phelps continued the business until 1937. Phelps Smith willed the wealth and property to establish Paul Smith's College, which specializes in liberal arts, forestry, and hotel management.

Contents

Acknowledgments 6

Introduction 7

1. Waterways, Spillways, Skidways 9

2. Midways 37

3. Airways, Railways, Roadways 69

4. Fairways, Parkways, Ski Ways 91

5. Pathways, Bikeways, Byways 105

6. Lifeways, My Ways 115

ACKNOWLEDGMENTS

Recording local history for today's readers and for those who follow ranks high on the list of to dos of our nation's heritage. It is a task that takes many and is most rewarding. Our thanks go to those writers who took the time to seek out local stories and put them into print. We also acknowledge the contributions of those who share their first-hand memories of days gone by so that they can be added to the printed literature of the region. Photographers, professional and amateur, from the onset of cameras provided those photographs that are worth a thousand words. And we acknowledge the contribution of the publishers who follow the quest to make those stories and photographs available for a widespread audience, today and tomorrow.

INTRODUCTION

The Adirondacks are among the oldest mountains in the world. Geologists theorize that the ancestral Adirondacks were formed about 1,100 million years ago by the heaving and buckling of layers of accumulated sediments. Exposed to erosion and upheaval of the earth's crust, the mountains had their ups and downs. The present Adirondacks emerged about 50 million years ago when all of North America expanded upward. Most of the higher peaks consist of the feldspar anorthosite, once the base of the ancestral Adirondacks, a hard rock that resists weathering and erosion.

The Adirondacks are unique. Once the hunting grounds of the Iroquois and Algonquin Indians, the region was likely named for *Haderondacks*, or "bark eaters," which is what the Iroquois called the Algonquins, who ate the inner bark of white pine trees, a source of vitamin C.

New York's Great Wilderness covers about a fourth of the state and consists of more than 2,000 peaks, 3,000 lakes and ponds, and 30,000 miles of waterways. The highest peak, Mount Marcy at 5,344 feet, was explored by Prof. E. Emmons with guide Nicholas Stoner and others around 1837. This exploration led, in time, to the establishment of the Adirondack State Park, a six-million-acre park—larger than Yellowstone, Yosemite, Glacier, and Olympic National Parks combined. Within the park is the Adirondack Forest Preserve, 2.7 million acres of state-owned lands established by the legislature on May 15, 1885, and designated by the 1894 Article 14 of the New York State Constitution to remain forever wild.

Adirondackers are independent, born of coping with mountain living and, some say, set in their ways. They ventured forth in the wilderness and developed their own manner and method of doing what had to be done to live in the forested mountains. The pathways and rough roadways opened the mountains to the hunters and trappers, loggers and camp builders, artists and writers, and thousands of visitors who sought the peace, challenge, and adventure the Adirondacks had to offer. And as people came, they introduced man-made contrivances into the wilderness. New routes and ways into the wilderness were built, and alongside them amusement parks, roadside attractions, golf courses, and ski centers were opened.

The wilderness did not easily lend itself to the building of railways. Those that were completed were built at a high cost in time, money, and labor. Dr. Thomas Durant of the Union Pacific Railroad built the Upper Hudson River Railroad at the end of the Civil War. In 1875, the line to Northville was completed. In 1891–1892, the Adirondack and St. Lawrence Railroad was built. The tracks and some of the depots that survived still run excursion trains through the picturesque, forested lake country.

The Fonda, Johnstown, and Gloversville Railroad bought land along the Sacandaga River near Northville in 1876 and eventually developed an amusement park there. Over the years,

many other amusement parks opened, including Santa's Workshop in 1948 in Wilmington and the Land of Make Believe in Upper Jay, both designed by Arto Monaco.

Golf courses were built in natural surroundings, and it was not uncommon to sight wilderness animals from the fairways. Winter sports proliferated after Melvil Dewey and his son started holding such events at the Lake Placid Club. Adirondack communities offered winter vacations, and ski ways were opened—at first just rope tows run by old cars, and later, full-fledged ski centers with T-bars and chairlifts.

Small airports were started to serve commuters wanting to fly their planes to their camps and summer homes. Some lakes offered runways for float planes, and Adirondack pilots set up passenger service to remote areas for hunting, fishing, and camping.

Official Adirondack byways were designated by New York State and named in honor of famous people or events and geographic sections. Among them are the Olympic Byway, the Roosevelt-Marcy Byway, the Route 73 Byway, Blue Ridge Road, Southern Adirondack Trail, Adirondack Trail, Central Adirondack Trail, and the Dude Ranch Trail.

The Adirondacks continue to lure sojourners and adventurers, to inspire artists and writers, to satisfy sportsmen and recreationists, and to rejuvenate all.

One

Waterways, Spillways, Skidways

Adirondack country is a land of waters. Waterways provided major transportation routes throughout much of the region's early history. Native Americans, hunters, trappers, settlers, soldiers, and guides did their traveling by water. Steamboats such as the *Mattie* on Lake Placid operated as early as 1800. And carries, overland portages, were developed to connect adjacent waterways.

Special waterways have been identified over the years for those who enjoy canoeing, guide boating, row boating, and white-watering. A 10-rivers region can be found within a 30-mile radius of the intersection of the boundary lines of Franklin, Hamilton, and St. Lawrence Counties and part of Essex County. A 100-mile paddle way can be taken from Old Forge to Saranac Lake. The seven-carries waterway begins at Paul Smith's College on St. Regis Lake and goes through 10 lakes and ponds for a distance of nine miles. The tour loops through several lakes and ponds including Fish Pond, Long Pond, Floodwood Pond, Rollins Pond, Fish Creek Ponds, Upper Saranac Lake, and Little Clear Pond. White-watering ventures are centered at Indian Lake, the Glen, Hadley, and the Hudson River.

Dams and spillways were added to increase the size and depth of many lakes, to provide power, to control flooding, and to offer better runways. The need for such dams eventually became the subject of controversy between preservationists and stakeholders.

Another benefit provided by larger bodies of water was the runways for the early seaplanes used in the Adirondacks for transportation and recreation. Flying provided wide views of the ocean of forested mountains and valleys. Hunters and anglers could get "back in" to search for game and fish. And Frank Reed, the flying preacher, could make his rounds of the lumber camps, preaching to the lumberjacks beginning in 1938.

When the white men found the Adirondacks, the waterways provided the transportation routes for exploration and settlement. Most traveled by boat, using the waters to visit neighbors, go to church or school, or go to the settlement for supplies. The waters made hunting and fishing major ventures in New York's wilderness. The escape routes during wartimes followed the waterways to Canada, and abandoned cannon have been found along the way. A Revolutionary War cannon is reportedly still in the Wilcox Lake area.

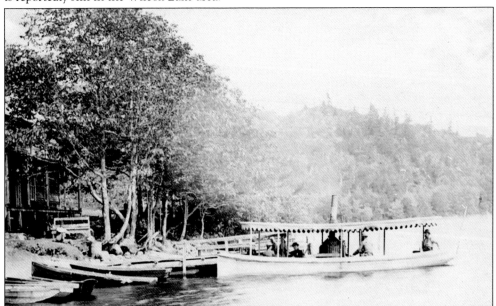

Transportation on the waterways evolved over the years from canoes and guide boats to the motorized boats of later years. In 1883, the naphtha launch was invented. Powered by naphtha, a petroleum by-product, these launches became the service boats of the Adirondacks. They carried the mail, transported guests, towed supplies and other boats, and carried animals. They were falsely labeled as being dangerous, and their use died out.

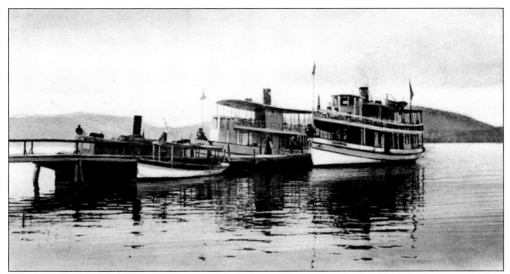

Lake Placid had steamboat *Mattie* in 1800, and Lake George had *James Caldwell* in 1817, but most steamboats appeared on the inner waterways during the last quarter of the 19th century. In 1878, Blue Mountain Lake got the *Utowana* and Lower Saranac Lake got the *Water Lily*. In 1883, the Fulton Chain of Lakes (Fourth Lake shown) got the *Hunter*. Steamboats lured guide boat business away from the Adirondack guides, who were thus accused of sinking Long Lake's steamboat *Buttercup*.

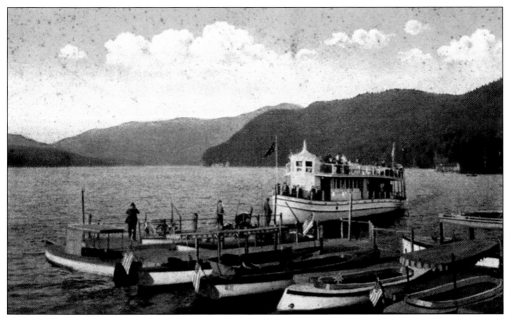

The steamers were the most efficient way to transport a large number of people to their destination. The 154-passenger steamer *Doris* made daily trips about the five-mile-long Placid Lake, offering views of camps, Mount Whiteface, and Pulpit Rock. Sailboat and powerboat races were sponsored by the Lake Placid Yacht Club, and the Shore Owners Association maintained a fireboat.

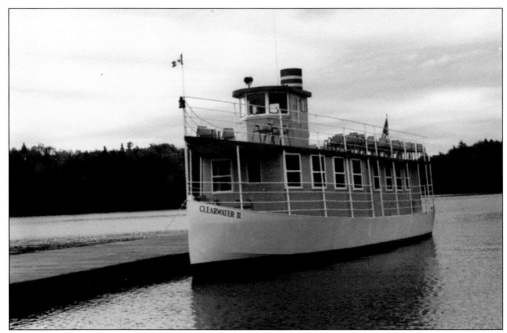

The *Clearwater* plied the waterways of the Fulton Chain of Lakes in the late 1800s and early 1900s when there were no roadways north of Old Forge. Once the roads were in, the *Clearwater* was dry-docked, and then during World War II, it was demolished for scrap metal. Today the diesel-run, double-deck *Clearwater II* offers 28-mile narrated trips through the Fulton Chain. The chain is named after inventor Robert Fulton, who speculated on a canal through the lakes and then determined it would be impractical. Although initially given names by early resident Lyon De Camp, the eight lakes have long been known by number. Pres. Benjamin Harrison had a summer white house on Second Lake. Woodsmen Nat Foster and Alvah Dunning made the chain their territory. In the 1890s, travel to the Fulton Chain railroad station took nine hours from New York City, topped off by a two-mile buckboard ride from the station to Old Forge.

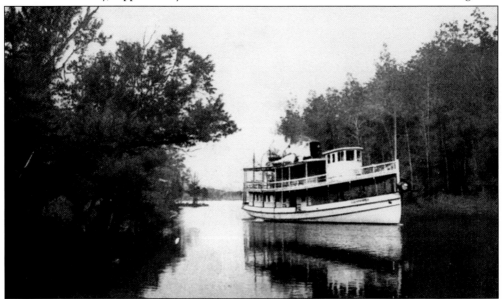

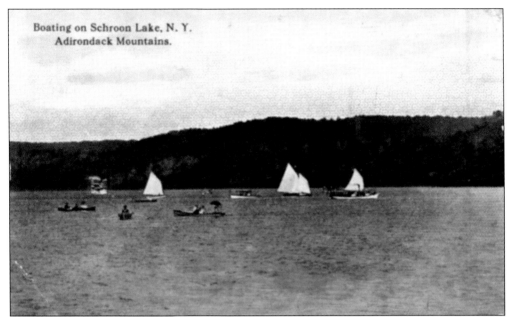

Boating on Schroon Lake included a variety of watercraft. This 1910 photograph shows steamboats, a naphtha launch, guide boats, canoes, and sailboats. Some of the lakes sponsored regattas that included racing by historic sailboats. Guide boat races are an Adirondack tradition that continues to this day. The message on the postcard mailed to Kingston says, "It is great up here, be sure and come up!"

Three couples in the rowboat enjoy an afternoon on Canada Lake, one of the waterways maintained by a dam. At one time, Canada Lake was reportedly Auskerada Lake, a Native American term meaning "many fishes." The 1893 Auskerada Hotel (background) was built by James Fitch Van Ness to replace the Canada Lake House, which had burned in 1884. The 100-room Auskerada had a dining hall on the first floor, a dance hall and parlor on the second floor, and guest rooms on the top three floors. A fire of unknown origin destroyed the hotel in 1921.

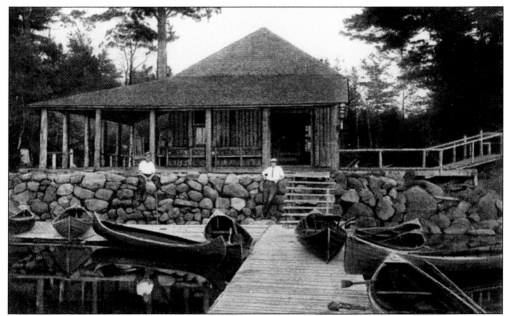

This 1920 view of Sacandaga Lake (not Great Sacandaga Lake) is compatible with the Adirondack wilderness. The rustic boathouse is made of logs with the bark left on. The wall of native stones holds back the bank of the lake. The dock is lined with lake boats, guide boats, and canoes. Wooden walkways lead from the Hotel Morley to the boathouse and dock, and the porch is furnished with rustic rocking chairs. The larger lapstrake lake boats were made at Speculator by John Buyce, a blacksmith who later ventured into the boat business.

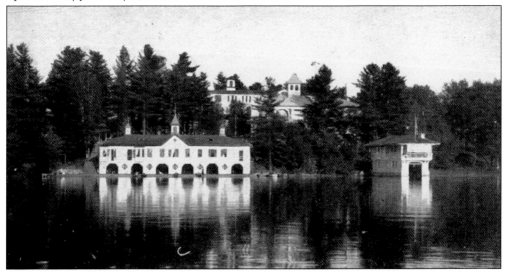

Part of the Loon Lake House complex, these elaborate boathouses are similar to those that once lined the banks of the Adirondack waterways. Most were built with access to the water so that the prized boats could be moored inside the building, out of the weather and out of sight. Often living quarters, sometimes for hired help, were built on the second floor of the boathouse, no longer an option on the Adirondack lakes. The big hotel at Loon Lake burned down in 1956. Much of the original venture at Loon Lake was sold to private owners, and one of the boathouses has been restored as a private home.

One of the best-known waterways in the Adirondacks is the Ausable River, cutting through a two-mile gorge at Ausable Chasm. The chasm was first opened to visitors in 1872. These large, staunch wooden boats once took visitors down the exciting ride through the flume. Information on the photograph compares the ride with shooting the rapids of the St. Lawrence River, "and the timid person need not hesitate to make the trip." Today rubber rafts have replaced the historic wooden craft that provided a safe and dry ride for over 100 years.

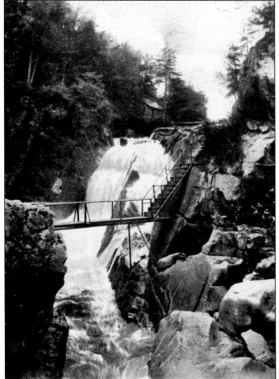

Wilmington High Falls has been a major waterway attraction for over two generations. Located on the West Branch of the Ausable River on the Olympic Byway (Route 86), the waterway performs a natural show for the viewers as it rushes through deep crevices for 700 feet. Bridges, groomed pathways, and platforms have been constructed to open the site for visitors.

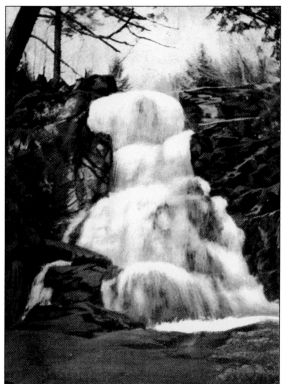

The waterways of the Adirondacks often pleased the artists and writers who sought inspiration in the mountains. Through their paintings and writings, they brought the Adirondacks to the outside world. One writer found Jimmie Creek to his liking and wrote a poem that was set to music: "When the summer heat is stifling in the crowded city street, And the ship drifts idly on the quiet sea; Ah 'tis then we seek respite from the cares of daily strife, and we come, Oh Jimmie Creek! We come to thee." The poem goes on with a chorus and two more verses praising this waterway found on the West Hill Roadway near Wells.

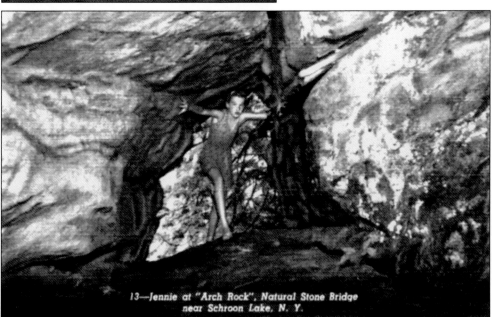

Lydia L. Neubuck, "the Cavewoman of 1950," developed the Natural Stone Bridge and Caves in Pottersville, where she lived in a home without electricity, plumbing, or telephone. She was guiding visitors through the caves before she was a teenager. An active spelunker, or cave explorer, she now lives in California and has recorded scientific data in caves all over the country. The Pottersville venture is being operated by the son of Lydia's sister Jennie (pictured).

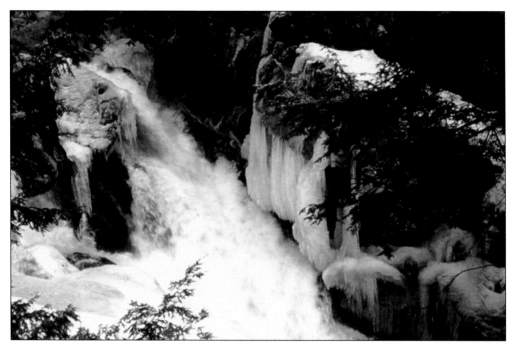

Auger Falls (Augar Falls or Olger Falls) on the Sacandaga River was once the site of a power dam, which required a caretaker who often had to make the half-hour hike to the dam by lantern light during the night to let the high water out. The river has cut through the rock, creating a flume and digging some deep potholes (shown). The potholes, some of which are four feet deep, were ground down over many years by small rocks that are swirled around by the fast-moving water. There is some danger in getting too close to the falls: a few years ago a photographer fell in, and the Wells Old Home Day parade was held up while an ambulance took him through the town.

Camping on islands has its advantages: privacy, cool breezes, fewer pesky bugs, and rarely an encounter with a wild animal. These two wall tents and a dining fly are on Mink Island at Tupper Lake, which was first called Tuppers Lake, possibly named after an early surveyor. (Photograph by H. S. Tousley of Keeseville, No. 15, Adirondac [sic] Stereoptic Views).

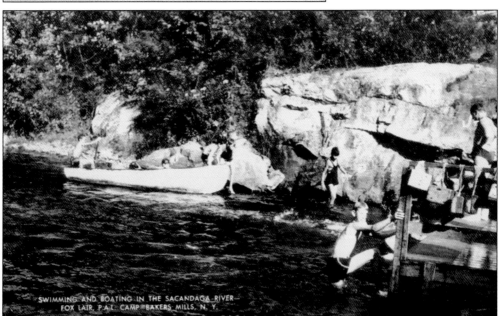

In 1938, the New York City police opened a summer camp for boys at the former Adirondack estate of the Hudnut perfume family. Each summer, 600 boys would arrive here from New York City. The east branch of the Sacandaga River provided a waterway for swimming and boating. The boys' camp closed in 1960, and the property became part of the New York State Forest Preserve. Some of it was reclaimed with the planting of trees, and today it serves as a campsite.

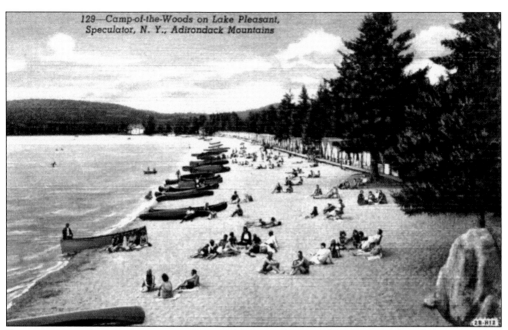

Every summer, thousands come to Camp-of-the-Woods on Lake Pleasant, founded in 1917 as a place "where city dwellers could enjoy the beauty and health-giving features of the Adirondacks."

This is the public beach at Old Forge. The diving float can be seen in the center of the lake, and the tour boats are in the background. Private boats are docked along the shore, and an inn is on the lakefront.

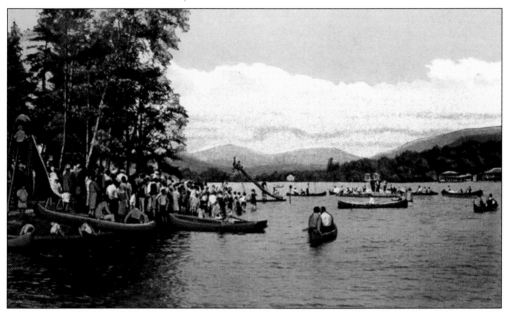

A large crowd has gathered on the municipal bathing beach at Lake Placid for an event. The beach offered water slides, a diving dock, canoes, and guide boats. Boat races and swimming races were held annually.

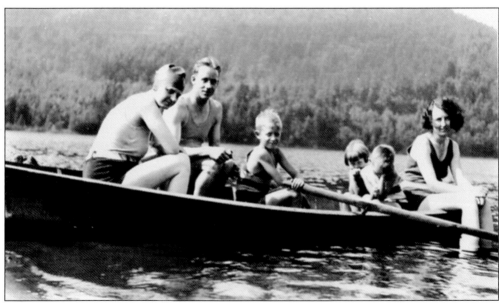

Marinas and boat liveries adorn the shores of many of the lakes. Boats were rented by the hour or the day and, in some cases, were furnished along with the accommodations at a hotel, camp, or cabin. Many summer visitors hired local girls to care for the children during their vacations; the young girl in the back of the boat may be the nanny for the three children.

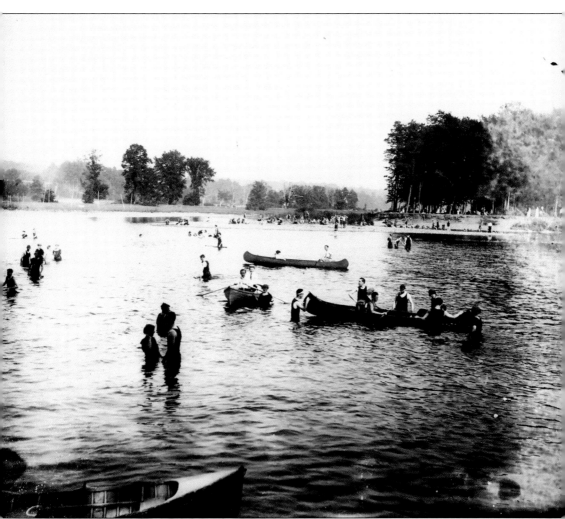

Visitors to Sacandaga Park had the Sacandaga River for water activities. Park caretaker Frank Phillips had two dozen metal boats for rent. Bathing suits could be rented, and changing rooms were available. To raise the water level, the park built two dams leading from Sport Island in each direction. The bridge to the island had to be removed during the annual log drive, when the logs from the forest upstream were floated to the downstream mills.

Boys were known to search out remote swimming holes for skinny-dipping. They would swing on a rope and drop into the cool waters. On occasion, when their privacy was intruded upon, they would have to stay in the water and dog paddle until the intruders left. One Adirondack guide would avoid taking clients to a certain water hole because of its popularity with skinny dippers.

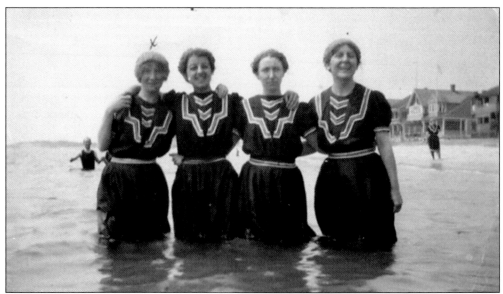

Practically the opposite of skinny dipping was the style of bathing suits. The well-dressed bathing beauties of the 1920s, 1930s, and 1940s wore bathing suits made of a lot of heavy material that left little skin exposed. Tanning was undesirable then, and parasols and beach umbrellas were used to keep off the sun. Men's bathing suits also consisted of a tank top and trunks.

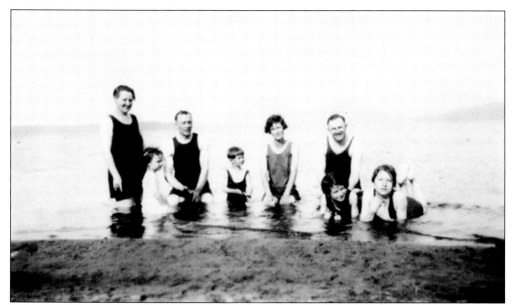

Adirondack beaches began to attract the swimmers in numbers at the beginning of the 20th century. The latest in bathing suit fashion was the modest suits modeled here. One male swimmer reportedly allowed his bathing suit strap to fall off his shoulder on a public beach exposing part of his chest, whereupon he was arrested and fined. In most communities, the bathing suits could only be worn at the beach and changing rooms were found at most of the beaches.

The early Adirondack loggers sent the logs to the sawmills down the white waterways of the rivers and streams. Today the white-water rafting companies, canoeists, and kayakers use the same waters for the exhilarating ride they provide. The Upper Hudson, the Indian River, North River on the Hudson, the Sacandaga River, and the Moose River waterways offer Class V down to Class I experiences. Kayaking has become a major recreation experience in the Adirondacks today, and hundreds of Adirondack guides are hired each season to take tourists down the rushing white waters in large rubber rafts.

Back in the 1940s, service stations would patch old truck tire tubes so they could give them to local children to use in the water. Tubing—floating on the current down the river in an old inner tube or rubber raft—is still popular today, and many children's camps provide tube trips on the rivers. Rivers long used for tubing include the Scroon, Hudson, Sacandaga, and Saranac.

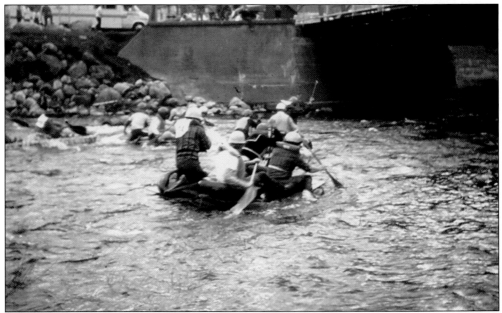

Races of all kinds—guide boat, canoe, bathtub, sailboat, and tube—provide entertainment for thousands during the warmest months. White-water trips by licensed guides have become a major industry on the larger rivers. As many as 70 white-water rafting companies may be found on any Adirondack river during the white-water season. Proper equipment for comfort and safety is provided, and accidents are kept to a minimum.

There were some bad days in the history of the Adirondack waterways, and one took place at Bloody Pond near Lake George. Gen. William Johnson (later Sir William Johnson) of Johnstown was battling the French in 1755 at Lake George during the French and Indian War. Soldiers, numbering some 250, from New Hampshire and New York regiments were sent to help Johnson. They found about 300 Canadians and Native Americans at Rocky Brook, whereupon they launched a surprise attack and slayed most of them. The bodies were thrown into the pond, which became known as Bloody Pond. Under Johnson, the British won the battle at Lake George, and, because of this victory, America became an English-speaking nation.

The Adirondack region has been called a "Land of Many Lakes." The lakes, with their sparkling waters, tree-lined shores, and forested backdrops, were not always accessible. There was a time when they were surrounded by dead trees and stumps and were so swampy that it was impossible to get to them. Dams were built on most of the lakes, and growing trees reclaimed the shorelines. Long Lake, in the views shown here, is one of the remaining lakes without a dam to raise its water level. Actually a wide waterway in the Raquette River, it is a favorite of anglers, boaters, pilots, and swimmers.

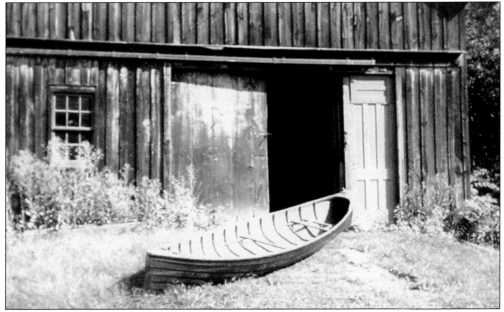

The guide boat, indigenous to the Adirondacks, is a cross between a rowboat and a canoe. It could be rowed with long oars across the lakes or paddled up streams with a paddle. Guides could also carry the boat between the waterways on shoulder yokes. With the stability to hold heavy loads of passengers and gear, the guide boat was the workhorse of the Adirondacks. Good guide boat builders gained a widespread reputation, and their vintage boats are priceless today.

Some credit Mitchell Sabattis, a Native American, with developing the first guide boat around 1840. Pointed on both ends, the boats can be rowed from two different positions in the boat, depending on the number of passengers or the load. Unlike the canoe, the wide boats did not tip easily, and with caned seats and lightweight shells, they could be carried on shore and used for shelters on a stormy night. Guides traditionally painted their guide boats blue on the outside and green on the inside, so that they would blend with the waters below and the trees overhead.

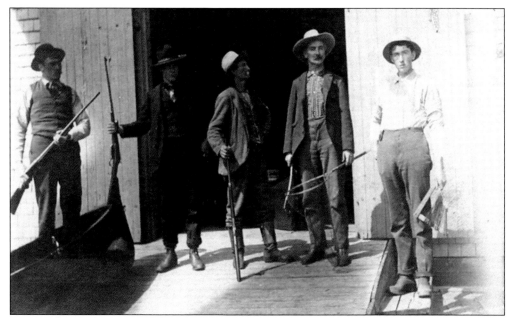

Equipped with their guns, fishing nets, and lines, these sports stand on the boat ramp, ready to go off on a hunting and fishing trip. The man on the right without a jacket may be the guide. Sports often wore their city clothes for hunting, and if their expensive Stetson hat got dirty on the trip, they might give it to the guide. So, for guides, it paid to have clients of the same head size and to make certain that some mud got on his hat while in the woods.

Friends relax on the bank of the West Branch of the Sacandaga River in 1912. From their dress, it appears that Arthur Whitman, William White, and James Crossley of Mayfield may have taken the trip directly from work. Once the automobile entered the scene, short trips to the waterside became a popular pursuit.

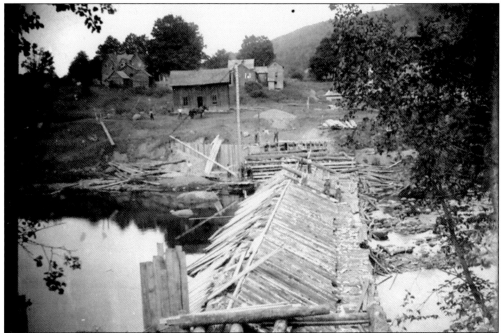

Damming the Sacandaga River at Wells served two purposes: a water supply for the nearby mill and a passage for the log drives that were held each spring. The dam had to be strong enough to hold back the water and also withstand the moving logs that passed over it. Built of heavy logs and native stone, it was set at an angle creating a spillway to serve both purposes. A sawmill used the Sacandaga waters in 1821, and later a tannery took over the site, followed by a wood products industry. Log drives continued until the 1950s. Those who drove the logs down the river earned $1.75 to $2 per day. Teams of horses were hired to get the logs to the riverbanks for $4 per day. River drivers were fed along the way on the drives, usually at someone's home since restaurants were scarce in the woodlands. The old logbooks of the drives record many names that have appeared in the long history of the Adirondacks: Dunham, Flansburgh, Simons, Stanton, Lobdell, Davison, Mattice, Degroff, Washburn, Lamphere, Burdett, Williams, Whitman, Wells, and White, among others.

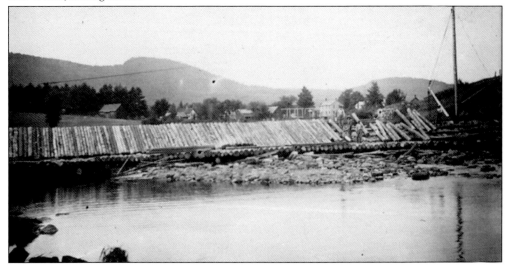

Remnants of the old log dams still stand along the rivers. Waterways were dammed in preparation for the spring log drives. Logs were piled on the banks of the rivers during the winter, and when spring came, they were pushed into the rushing waters. The dam was opened, and the logs floated downstream to the mills. The Adirondack waterways were declared "public highways" in the middle of the 1800s so that they could transport the logs. River drivers had the dangerous job of keeping the logs from jamming and moving them down the river. They took pride in not losing a log by making certain that those caught along the riverbank were pushed back into the water.

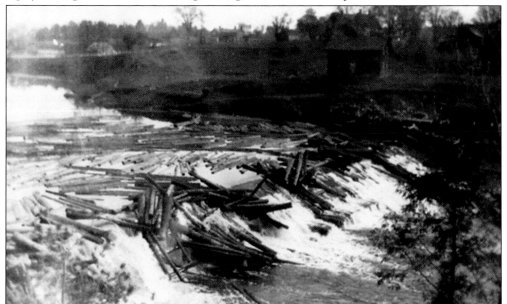

It was a major task to float the logs to market over the spillways in the Adirondacks. From the 1850s to the 1950s, log drivers rode the logs with their pike poles and peaveys to move them downstream. Sometimes heavy workboats and dynamite were used to move the stubborn logjams. Occasionally, on a tough drive, the drivers might make as much as $3 per day. In the middle of the 1800s, New York State became number one in the country in timber production.

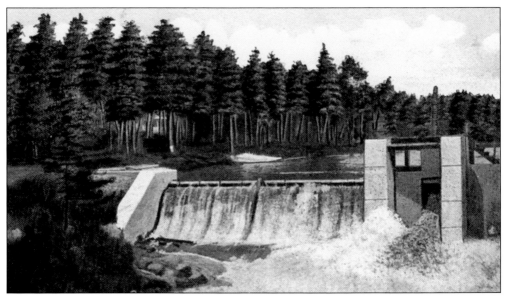

There are dams and spillways found on some 945 waterways in the 12 Adirondack counties, with 378 of them of significant size. Others have been proposed over the years, but public outcry and general opposition put all dam building on hold in 1969. The dams were built for drinking water, canal use, flood control, power, and fish hatching beds. Today the existing dams are credited with providing recreational opportunities, second home locations, and income production. The dam shown here on the Fulton Chain of Lakes holds up the water level for the many tourist and resident uses of the waters for swimming and boating.

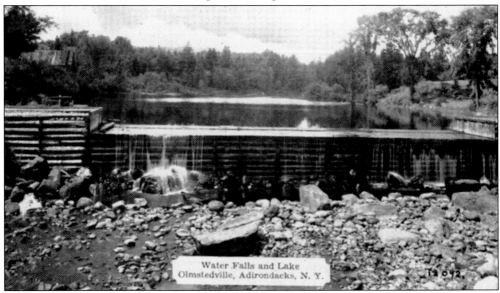

Spillways made of logs are common on the Adirondack waterways. Many of them had their origin during the big logging days before log trucks came into use. In the small communities, the local brooks were dammed up to create ponds for swimming and fishing, bringing an economic boost with the influx of summer tourists. In the Adirondacks, the terms lakes and ponds are interchangeable, there are lakes smaller than ponds and ponds bigger than lakes. No standard size has been defined, and local custom determines the name given to the waterway.

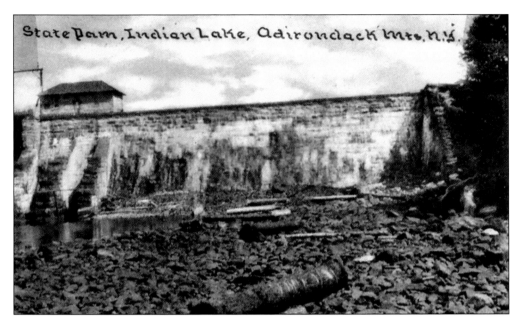

Indian Lake was created by an 1898 dam built on the site of two smaller dams used for logging purposes. The 14-mile lake created by the dam flooded three smaller lakes to create the one larger body of water and raised the water level more than 33 feet. The dam controls some of the downstate flooding and protects 18 species of fish who breed here. The islands in the lake are popular camping locations maintained by the New York State Environmental Conservation Department.

Sacandaga Park was developed by the Fonda, Johnstown and Gloversville Railroad as a major amusement park. Two dams were constructed to hold back the river and create deep ponds for the swimming beach and boats. Two dams were needed because of Sport Island located in the middle of the river. The dams were built with timbers and planks held by rocks. A spillway to move the ice flow and logs over them was built by planks on the upstream side attached to the top of the dam and sloped to the riverbed.

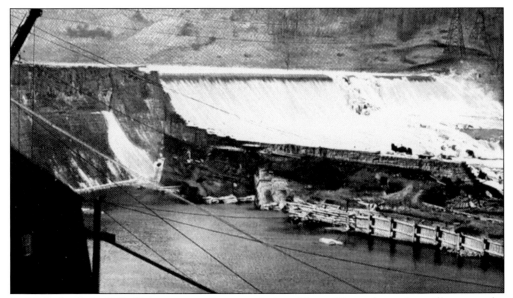

In 1907, the Spier Falls Dam was nearing completion. The spillway shown here illustrates the amount of water coming over the dam. Spier Falls is on the Hudson River near the eastern boundary of the Adirondack Park. Millions of logs from the Adirondacks, which were floated down the Sacandaga River and Hudson River, had to pass through here on the way to the "Big Boom" at Glens Falls. Without raising the water levels on the waterways, many of the logs would have jammed up and never reached the market. In some cases, it took two seasons for the logs to make the entire trip because of the water levels.

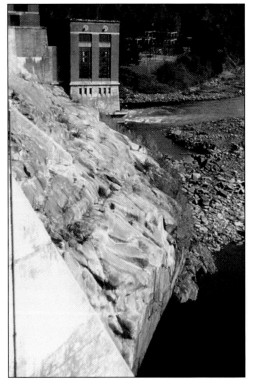

The spillway's channel base at the Conklingville Dam control house for the Great Sacandaga Lake is 76 feet below the top of the dam and is 20 feet wide. The channel itself runs from the roadway some 400 feet to the powerhouse. The dam holds back the water to prevent downstream flooding in places like Albany and also to generate power. Several industries down the Hudson River also make use of the released water. Over half of the water that feeds the Great Sacandaga Lake comes down the Sacandaga River.

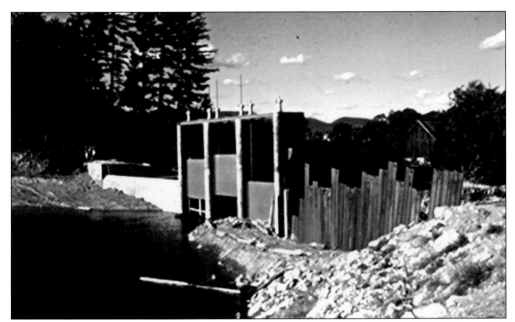

Adirondack dams, with their spillways, control much of the water in upstate New York. Built for flood control, for power, and for raising water levels, the dams are doing their job. Here a new $190,000 dam is under construction in 1959 on Lake Algonquin in Wells. The old wooden dam was bypassed with a washout in a disastrous flood in 1949 during a winter thaw and rainstorm. Temporary dams were a problem, so the new dam was proposed to secure the lake once and for all. The voters approved, and today the dam is providing electric power, as well as recreational opportunity.

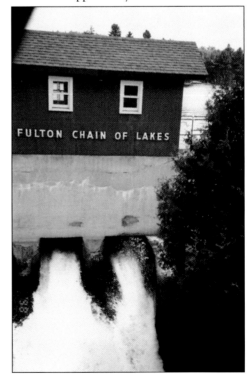

The spillway on Old Forge Pond on the Fulton Chain helps to maintain the water level. Water levels have been important to the economy of the Adirondacks over the years. Levels must stay up to allow the large boats to provide the traditional sightseeing and dinner cruises on the Fulton Chain of Lakes for the tourists. Boat tours of the chain have been offered since the 19th century.

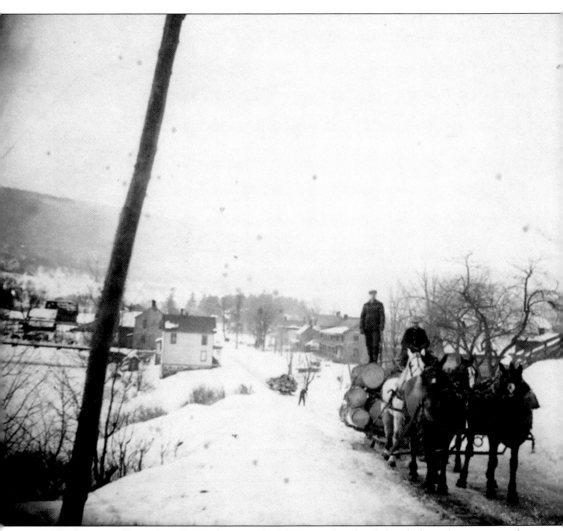

The horses pulling these heavy logs are double-teamed to haul the sled up the snowy inclines. Logs were hauled to the skidways on the riverbanks during the winter so that when spring came they could be pushed into the fast-moving waterways to float to the downstream sawmills. Local settlers made extra money by working on the drives and renting their horses to the lumber companies. The lumber companies hired an employee to go through the Adirondacks before winter and arrange for the teams. Another sled of logs waits at the foot of the hill for the horses to come back and haul them up.

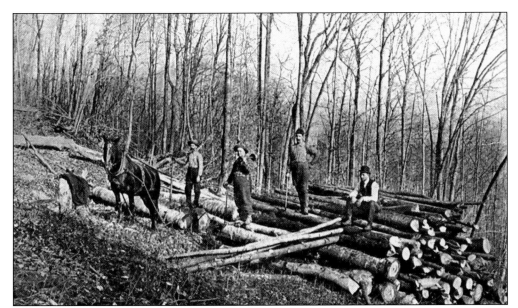

Foresters developed the determination, drive, and skills needed to get the logs to market. Cutting the giant trees with an axe or crosscut saw took men of muscle and stamina. The logs had to be cut to size, moved on the skidways, dragged to the riverbanks, and pushed into the rivers. There river drivers moved the logs downstream to the mills. Logjams had to be dislodged with pike poles, peaveys, or dynamite to keep the logs moving. Foresters could be hurt or killed when trees or branches fell, and drivers when they slipped and went under logjams. The lumber camps were crowded and lice- and bedbug-infested. Feeding the men meals large enough to keep them healthy and working was a major undertaking. When the annual work in the lumber camps was finished, the men often collected their pay and headed for the nearest town to burn off some steam. Stories are still told in the logging towns today about the actions of the lumberjacks when they hit town.

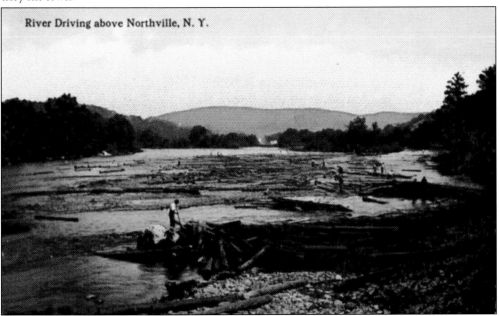

River Driving above Northville, N. Y.

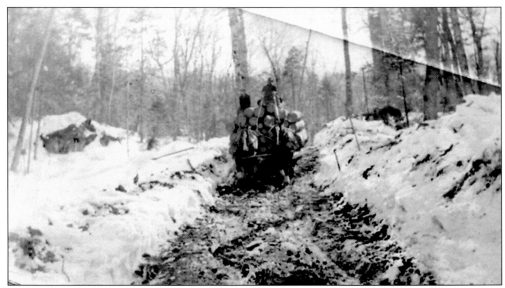

Working in the winter snows, moving the logs on the skidways and icy roadways, was not easy. The roadways had to be prepared, plowed, and covered with water to create an icy surface for moving the heavy logs on sleds. Men equipped with sand had to be stationed along the roadways to throw sand on the ice to slow down the sleds so they would not overtake the horses. It did not pay to get into a fight with the sand men if you were driving the horses the next day. Heavy underwear and socks, and wool pants and shirts helped to keep out the winter cold.

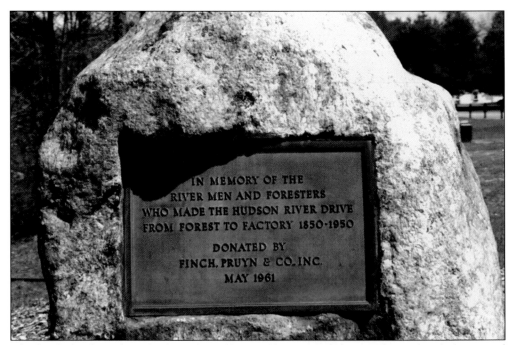

The hardy lumberjacks, who brought millions of logs out of the woods on the skidways and herded them down the fast-moving spring rivers, are remembered by a plaque along the upper Hudson River. It was erected by the Finch and Pruyn lumber company in 1961.

Two

MIDWAYS

Those seeking to get out of the populated areas to enjoy the attractions of the Adirondacks soon wanted more than what the trees and waters had to offer. Large groups from businesses, factories, and organizations sought out the beaches and picnic groves for their annual employee outings. It was not long before the need for additional ways of amusing the crowds became apparent.

Amusement parks offered opportunities for gatherings of all kinds. Sunday school children, glove shop workers, church organizations, newspaper boys, and other such groups came to the playlands to play ball, wrestle, box, bowl, roller-skate, take boat rides, ride donkeys, enjoy the waters, listen to the big bands, dance, and hike the pathways. To this were added the midways with their roller coasters, arcades, Ferris wheels, bumper cars, merry-go-rounds, and games of chance.

Cartoonist Art Monaco designed the nation's first actual theme park, Santa's Workshop, in 1948 at Wilmington. He later created the 85-acre Land of Make Believe along the Ausable River at Upper Jay, which opened in 1954, a year before Disneyland.

In its day, Sacandaga Park, a creation of the Fonda, Johnstown and Gloversville Railroad, was "the Coney Island of the North." This "Gem of the Adirondacks" attracted trainloads of people each day, 100,000 visitors per summer season. Name bands played concerts. Nationally known performers and vaudevillians appeared, and major events took place at Sacandaga Park.

The amusement parks reached by railroad lines enjoyed great success before the widespread use of the automobile. Trains from around the country connected with the Adirondack railways and transported hundreds of vacationers during the season. Once the automobile came into common use, however, the crowds began to scatter and the amusement parks reached by train lost their throngs. Those amusement parks in resort areas easily reached by automobile survived into the last quarter of the 20th century.

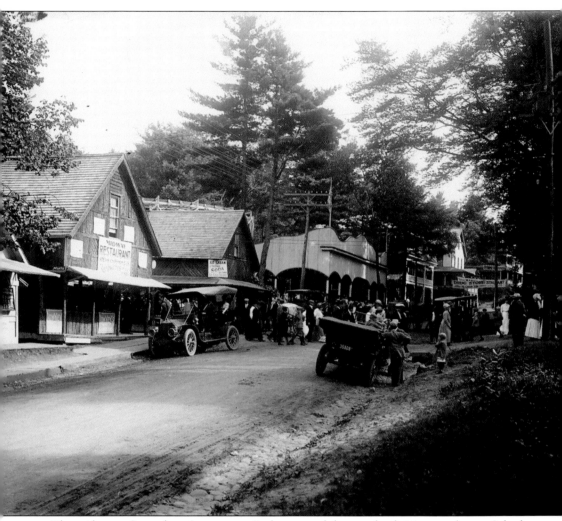

The midway at Sacandaga Amusement Park attracted thousands of visitors each year. It had two merry-go-rounds, a shooting gallery, a fun house, bowling alleys, a donkey ring, a photography studio, a roller coaster, a roller-skating rink, and refreshment stands—one of which made the first cotton candy. The midway was closed in 1930 when the Sacandaga River was dammed up, creating today's Great Sacandaga Lake. The park offered rustic theater productions and, later, silent films and an electric theater, vaudeville, Sport Island with its sporting events, waterfront activities, dancing, band concerts, and donkey rides. Special events included hot-air balloon flights, air shows, and military encampments. The addition of the 250-guest Adirondack Inn made overnight trips to the park available to more visitors. Fire was always a worry, and after a bad fire in 1898, when 110 cottages were burned down, a reservoir was added to the park.

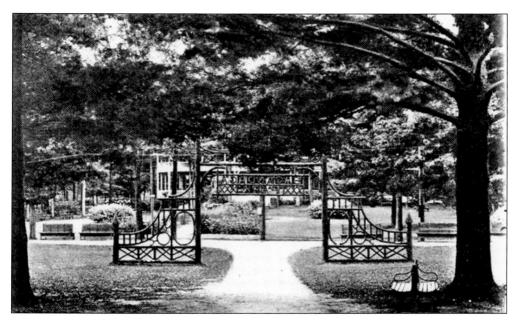

Landscape architect Chapman was hired by the Fonda, Johnstown, and Gloversville Railroad Company to add a rustic motif to Sacandaga Park. He created picnic grounds and wooded pathways amidst the park's miniature lake, rustic bridges, twig arbors, and picturesque gardens. The large rustic gateway in front of the Adirondack Inn typified the Adirondack style. The words Sacandaga Park were spelled out in the gateway with twig work. The use of rustic materials became an art form at the beginning of the 19th century, with souvenir pieces, furniture, fences, and bridges constructed of twigs and logs. For some uses the bark was left on, and for others the wood was peeled and highly polished. Any original rustic pieces left today are highly collectible. Some of the prizes and souvenirs offered at the midway in the park were made of Adirondack wood and reflected the rustic tradition.

Sacandaga Park began its life in 1876 as a Methodist camp meeting ground. The Methodists shared the grounds with temperance groups and the Salvation Army until an influx of partygoers made the site unacceptable. The noisy, drinking revelers did not mix with the church services. The Fonda, Johnstown, and Gloversville Railroad Company purchased 750 acres and began expanding the park in 1902.

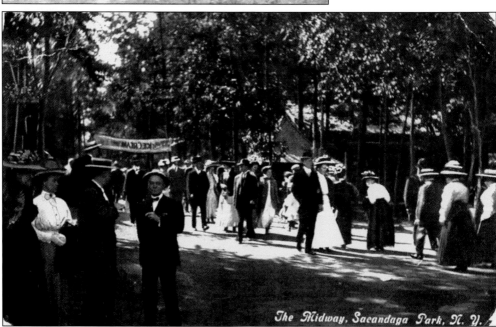

The midway at Sacandaga Park was always filled during the season by well-dressed patrons from the big cities. Glove and leather manufacturers in Fulton County, "Glove Capital of the World," held their annual picnics at the park with organized games, races, tennis, golf, and other activities for hundreds of employees. Church groups made the park their choice for summer outings. Parkgoers also got to attend one of those newfangled moving picture shows.

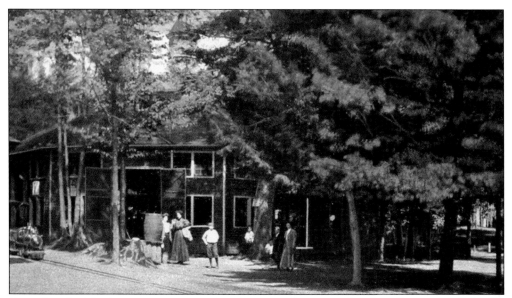

Sacandaga Park had two merry-go-rounds—the originals were works of art. One was made by the Gustav Dentzel factory of Philadelphia with the full-size hand-carved horses with real horsehair tails and other animals, totaling 40. It was decorated with canvas paintings of deer and had a brass ring attachment. Those who could grab a ring while going around got a free ride. Today the priceless merry-go-round is housed at the Shelburne Museum in Vermont. Some of the realistic figures carved by Daniel Carl Muller are in the Smithsonian. The sister merry-go-round, an all-horse, up-and-down machine, was made by Herschell-Spillman in North Tonawanda.

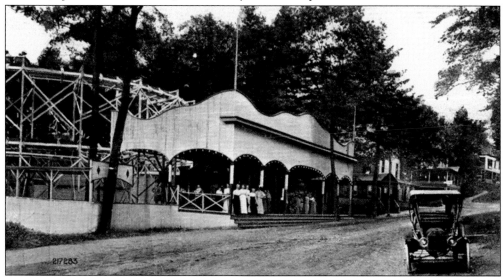

The roller coaster became one of the main attractions at Sagandaga Park. It helped to make the popular vacation destination "the Coney Island of the North." Once the roller bearings were invented, the old scenic railways or toboggan slides gained new speed and became known as roller coasters. A framework of timbers, some four stories high, supported the figure-eight roller coaster. Roy Eddy was the manager of the ride and, with a manually operated brake, made certain that there were no accidents. The ride had a sudden downward plunge that struck terror in the hearts of the riders, but they always came back to ride again.

Donkey rides brought people of all ages to Sacandaga Park. Hollis Johnson, "the donkey man," took care of the animals and rented them out for rides. The 10¢ tickets were printed with burros, another name for the donkeys. When they were not working, the donkeys were pastured on Sport Island behind the grandstand.

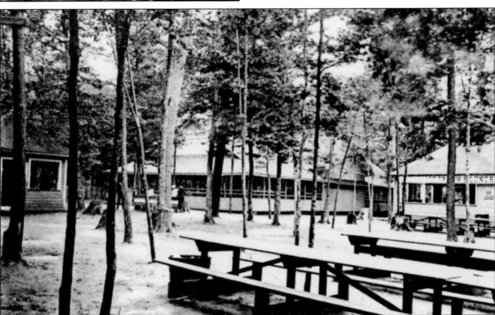

The Sacandaga Park venture began as picnic grounds with a dancing pavilion. The Fonda, Johnstown, and Gloversville Railroad Company bought lands along the Sacandaga River near Northville to attract city people to use their railway line for transportation to their outings. The railroad bought the former Methodist camp meeting grounds and expanded the park by adding the family-oriented attractions.

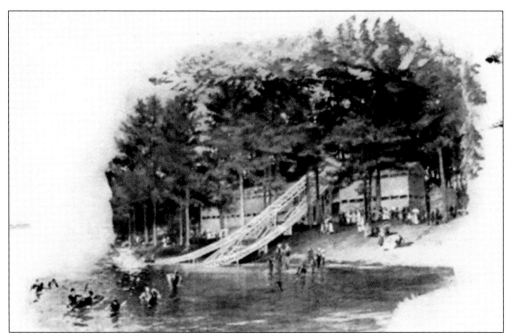

Sacandaga Park was offering water toboggan slides beginning in 1900, along with canoes, guide boats, and a swimming beach. The toboggans were pulled back up the bank by a special gas-powered chain. They were called "shoot the chutes," and on one old postcard they were "schute the schutes." Dyde Russell operated the water slide.

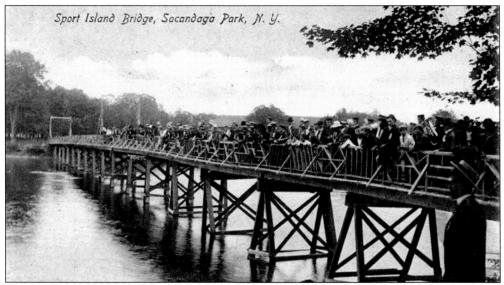

Sport Island, with a picnic area, grandstand, and baseball diamond, was added to Sacandaga Park in 1901. The New York State Baseball League scheduled games there, and it became the home field of the local JAGS Ball Club. When cities could not hold Sunday games because of the blue laws, they would play the games on Sport Island. The bridge to Sport Island had to be removed and reconstructed on giant sawhorses each year to keep the ice from destroying it and to let the logs pass through to the mills. In 1917, a late spring and rising waters caused the logs to hit the bridge.

A wedding takes place at Sport Island at Sacandaga Park. A miniature train took patrons to the island for boxing matches, wrestling bouts, fireworks, balloon ascensions, and Native American pageants. A 1918 fire destroyed the grandstand, built by chief carpenter Charles Osborn, and also burned the miniature train parked underneath. When the river was flooded by the 1930 dam, the island went below the surface.

Souvenir photographs were purchased as keepsakes of the trip to Sacandaga Park. For 5¢, the "Sacandaga Hermit," Stuart Wilson, took tintype portraits, which became mementos of the park. Viola Whitman, pictured at age 15, could take the train from her home in Mayfield for 25¢ and spend the day at the park. The Mann Brothers Photo and Portrait Studio was on the midway.

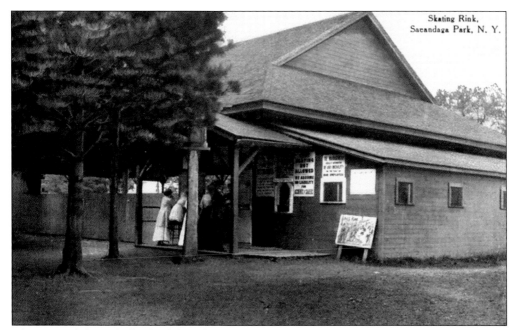

The original dance hall, which later became a skating rink, is still standing at Sacandaga Park. Free dancing and free skating were often advertised in the newspapers to entice customers to come to the park. Free tickets were offered, much like today's coupons. Patrons of the dance hall enjoyed the dime-a-dance program.

The concert park had a rustic bandstand and benches. Well-known bands played at the park on a regular basis during the season. The John Phillip Sousa Band, Boston Symphonic Orchestra, Remington Typewriter Band of Ilion, and E. W. Prouty Orchestra were featured during the park's heyday.

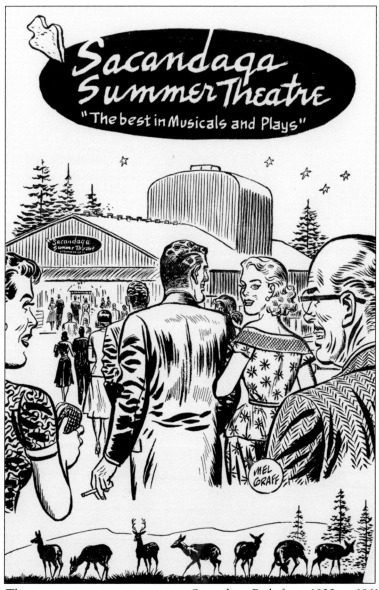

The Rustic Theater was a major attraction at Sacandaga Park from 1900 to 1961, when the theater was closed and the building was sold to a church parish in Guilderland. The original theater, built of Adirondack logs, offered vaudeville, concerts, and silent movies. The Rustic booked some of the biggest acts of the day: Eddie Cantor, W. C. Fields, Harry Houdini, Al Jolson, Marlene Dietrich, and Frederick March. After fire destroyed the log building in 1955, the theater was rebuilt with modern materials and it became home to the Sacandaga Summer Theatre, with actors that included Groucho Marx, Charlton Heston, Linda Darnell, and Victor Jory, and playbill covers designed by syndicated cartoonist Mel Graff of Northville. The theater became a community enterprise, with volunteers from a women's auxiliary, investments from local business people and others who formed the First Nighters Club, supervised parking by the Northville Firemans Association, and proceeds from Anthony Brady Farrell Productions concession stands. Low attendance and a noise problem from rain beating on the metal roof resulted in the closing.

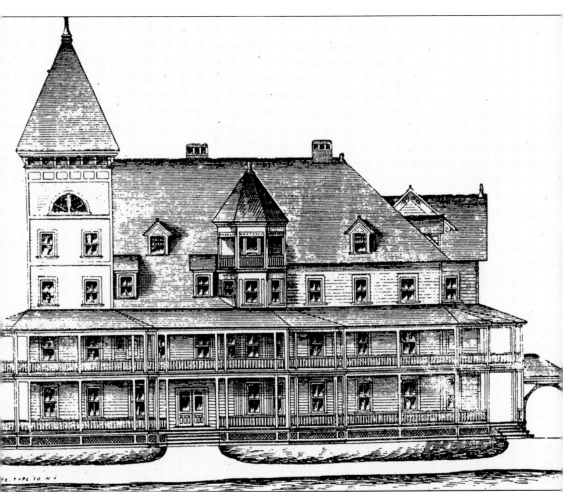

This architect's drawing of the Adirondack Inn, Sacandaga Park's new hotel, appeared in an 1890 book entitled *Industrial Advantages of Gloversville*. The inn, owned and operated by the Fonda, Johnstown and Gloversville Railroad, was built for 250 guests. Designed by Architect Hoffman of Albany, the inn was a first-class hotel. The hotel had pool tables, a bowling alley, and was a place where manager W. E. Bush promised "special attention given to the ladies." Organizations and clubs from around the country used the Adirondack Inn for their annual meetings and conventions. By 1937, all rooms had telephones and hot and cold running water. Inn brochures relate, "It has been reared to meet the discriminating tastes of a cultivated public!" Concerts were held on the lawn of the inn, and dances were held in its ballroom. Meeting the fate of many old hotels, the Adirondack Inn burned down in a suspicious fire in September 1975.

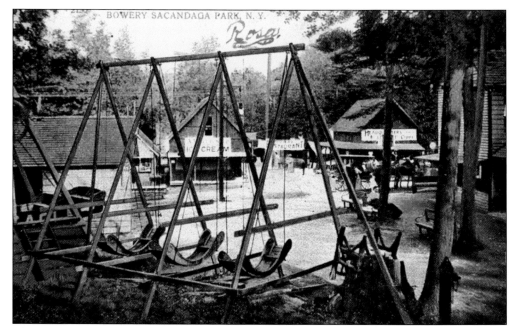

The Sacandaga Park midway included the Bowery, a section with ice-cream stands and restaurants. The swings (foreground) and the horse and buggy (background) were available for rides. Two large teams of horses pulled visitors on straw rides. Factories, church groups, and organizations held annual outings at the park, many of which were reported in the newspapers of the day: in July 1927, 100 members and friends of the Johnstown Camp, Golden Seal Assurance Society; and on August 26, 1909, the 30th annual mammoth picnic of leather tannery Booth and Company, featuring 14 athletic events, a 100-man tug-of-war, and a double-header baseball game.

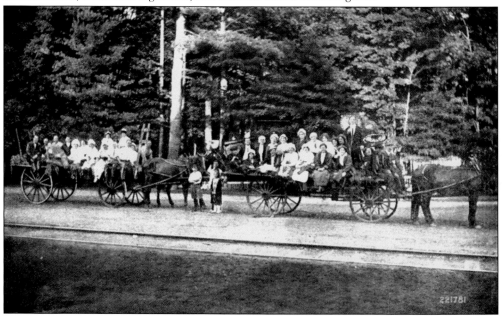

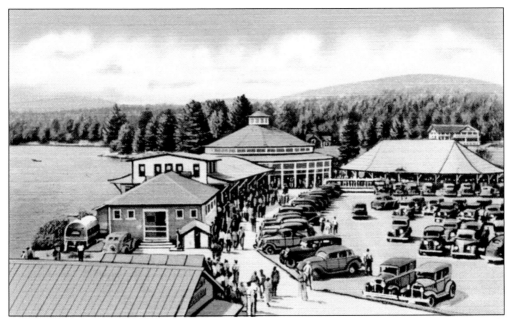

In 1920, Frank Sherman created Sherman's Amusement Park in the popular Caroga and Canada lakes area of the southern Adirondacks and established its slogan: Just for Fun. The park had a midway (pictured), bumper cars, tilt-a-wheels, paddle boats, a Ferris wheel, a carousel, and a swimming beach.

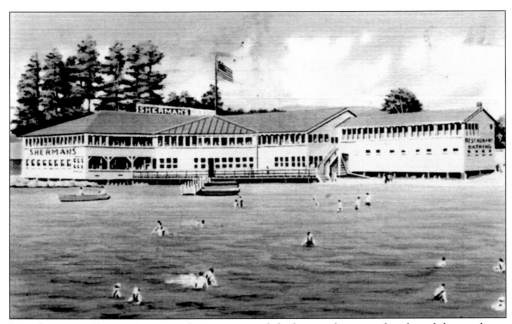

In earlier years, Sherman's attracted capacity crowds by hosting big name bands and dime-a-dance sessions. Today owners Ruth and George Abdella continue the dancing tradition with a 200-capacity dance hall upstairs and accommodations for 400 downstairs. The park has become a choice location for weddings and other parties.

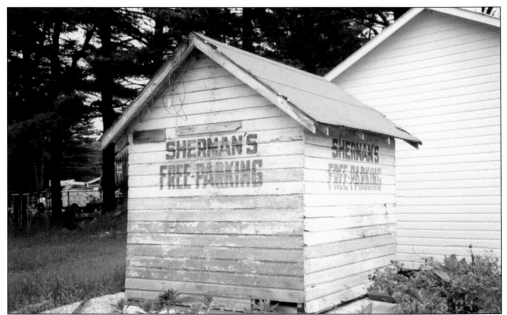

Remnants of the heyday of Sherman's Amusement Park can be seen on one of the old outbuildings. Free parking was important to the midways as automobiles came into widespread use. The Caroga Lake amusement park growth began in 1910 with a small park behind Vrooman's Hotel consisting of a small merry-go-round and a small midway with games of chance. It was a venture that caught on with the public and grew with the crowds.

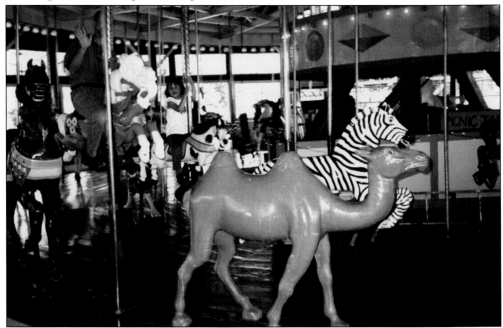

Although most of the original rides on Sherman's Amusement Park's midway have been discontinued, the refurbished carousel is serving the latest generation of parkgoers. New colored-glass windows and animals reflect the days of the old merry-go-rounds. Those who loved the ride 80 years ago now bring their grandchildren to enjoy the same.

The Ferris wheel at Sherman's has been restored but is not currently in use. The original Ferris wheel, invented by G. W. G. Ferris, was introduce at the 1893 Chicago World's Fair, and the one installed at Caroga Lake in 1920 became one of the first to be used by the public.

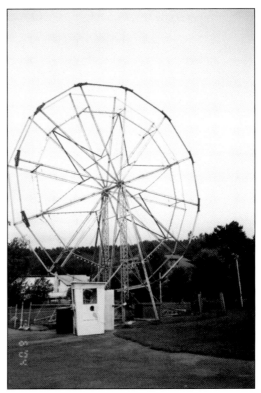

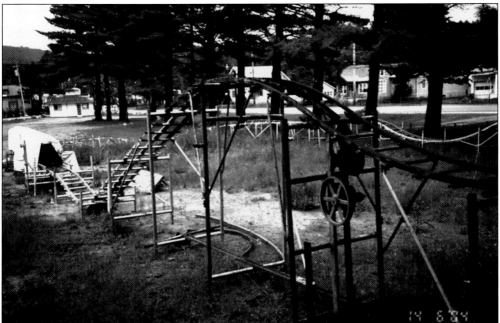

The once-popular roller coaster from Sherman's Amusement Park's midway stands in mute testimony to the days gone by. Rising insurance costs and competition from other venues have contributed to the discontinuation of the old coaster and other rides. No one knows how many took the thrilling ride on the coaster, screaming as they whipped up and down its dips and hills.

The bumper cars were the most popular ride on the Sherman's midway. The cars were propelled by electricity wired to the cars through the ceiling conductors. A pipe reaching from the cars to the ceiling carried the electric current. When the cars were moving around the floor, sparks would fly from the ceiling, where the contact was made from the car. Head-on collisions were prohibited, but cars crashed into each other, and sometimes several piled up, causing a delay in the action.

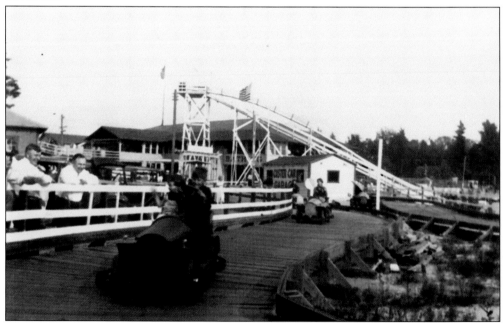

The Custer cars ran at Sherman's from sometime after the opening in 1920 to the 1940s. After Frank Sherman's death, the park was operated by his two sons, Frank Jr. and Floyd Sherman. It was downsized by the 1960s, was closed for a time, and then was brought back to life with a full schedule of music programs.

Sherman's Yellow Rose Complex at Caroga Lake continues the traditional big band entertainment with a seasonal program of the major area bands. Back in the 1920s, patrons lined up for the dime-a-dance sessions. The original building still in use held hundreds for the Ray Anthony Band with Frankie Carle on the piano. Name bands played every weekend, and orchestras played until midnight on Sundays. Some remember Dan Murphy's Band, Glen Greigs Orchestra, Jimmy Lunceford, Doc Dayton, the Gibbons brothers, and Saxy Marshall's band. There was no drinking allowed and no wild dancing practiced at Sherman's in the 1900s. Patrons came to enjoy the ballroom dancing and other slow dancing of that day.

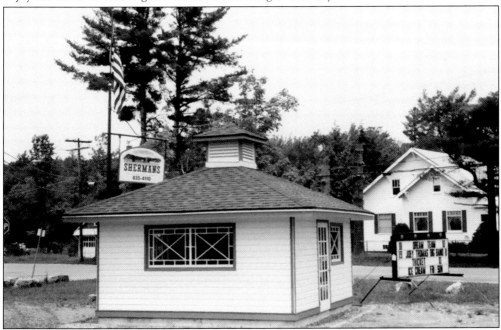

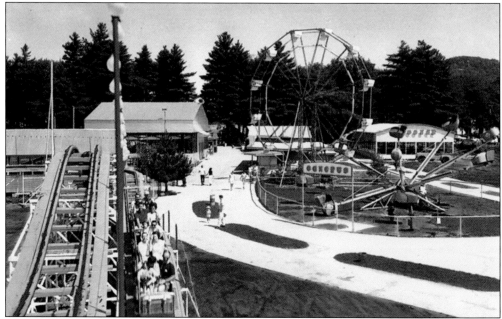

The Pine Lake Recreation Park advertising boasted "the Largest Amusement Park in Central New York" and "the finest Bathing Beach in New York State." They offered amusement rides, kiddie rides, a roller coaster, the whip, a merry-go-round, and a Ferris wheel. It took three weeks each winter to cut the 1,100 cakes of ice from the lake to keep the park supplied in the summertime.

The Pine Lake Amusement Park began with a dance hall built in 1925 by Joseph Goshans. Goshans later added a picnic grove, a water slide on the beach, and an amusement park. In 1961, it officially became the Pine Lake Amusement Park under the ownership of Robert Lord. The 1968 map of Pine Lake Amusement Park includes a bathhouse, beach house, store, pavilion, Timberline lodge, Pizza House, first aid station, children's rides, Bingo Barn, a picnic area, a midway, miniature golf, and a contest and game field.

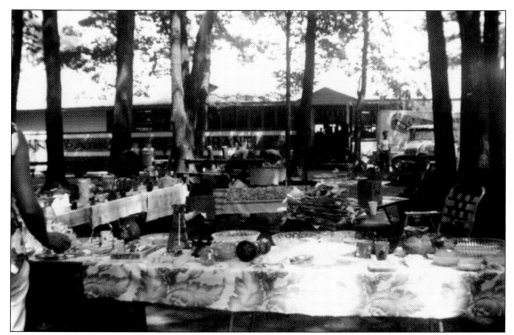

For many years, Pine Lake held weekly flea markets during the warm weather. Dealers came from miles around to sell their wares to residents and visitors who were looking for bargains in antiques and collectibles. Native Americans also offered craft items for sale. Summer residents found the flea market a good place to find a rare item to take back to their city homes.

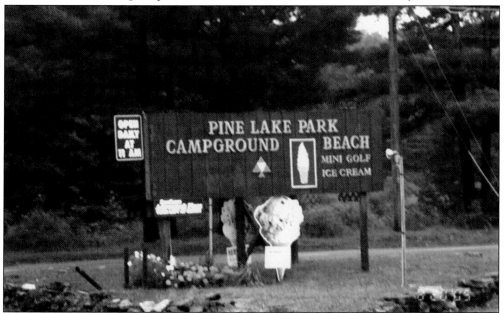

Today the Pine Lake midway is gone, and the rides are no more. The beach, picnic area, dance hall, and pavilion still welcome the visitors. A campground, a miniature golf course, and an ice-cream stand have been added. The park was once used for company outings, with such contests as balloon blowing, horseshoe pitching, roulette, ring toss, dice toss, watermelon contests, an obstacle course, and sack races.

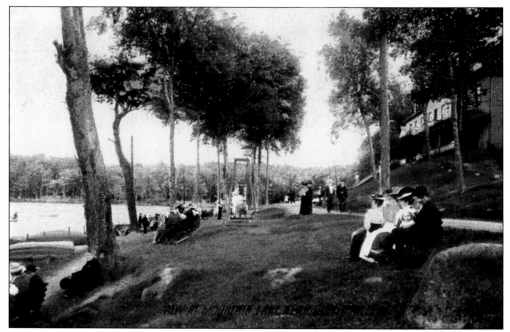

The Mountain Lake Resort near Gloversville was a center for dancing, concerts, swimming, sports, and gatherings of all kinds. It was popular from about 1900 to World War I. Lou Weber's Orchestra and Parkman's Orchestra attracted a crowd for the Saturday night parties and the big Fourth of July celebration.

School groups, church groups, and company and organization gatherings were attracted to Mountain Lake for their annual outings. The newspaper delivery boys from nearby cities enjoyed an annual outing to the lake, where they enjoyed swimming and baseball along with "sassprilley and sodey water." Big delegations came from New York City to enjoy the Adirondacks. The boys shown here are enjoying some fishing, with one pulling a rather large fish from the lake.

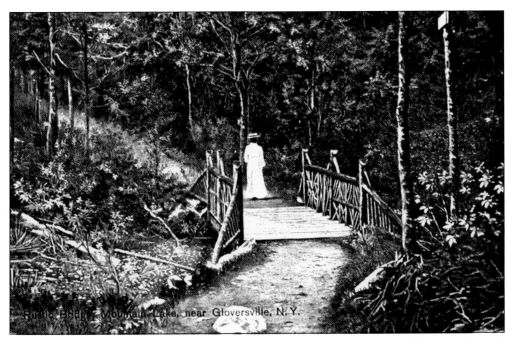

The pathways at Mountain Lake included rustic bridges and fences. The well-kept trails could be enjoyed by the ladies dressed in their floor-length finery and by gentlemen in their best bib and tucker. The rustic woodwork was part of the landscaping. The castle like structure was at the lake.

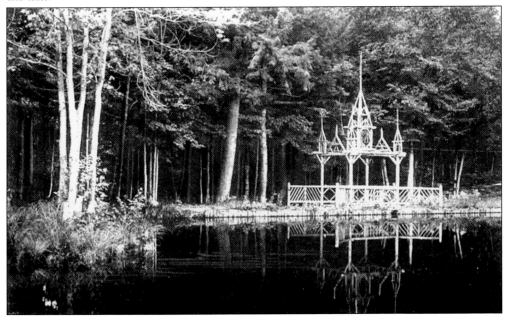

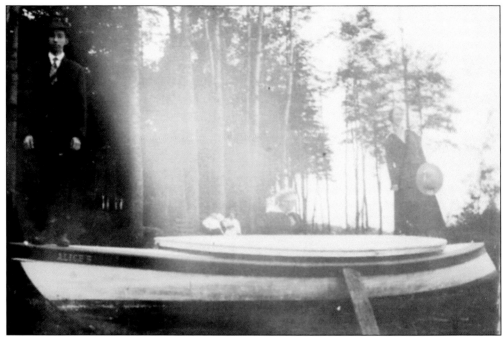

Boating was one of the main attractions at the outdoor parks. The *Alice B* (pictured) was used on Mountain Lake, as were larger canopied boats that took visitors around the lake. When Mountain Lake was settled in the early 1800s, it was known as Carpenters Lake. Once the Adelphia Club had formed a company and built the hotel, casino, shooting gallery, and the boating and bathing facilities, the name was changed to Mountain Lake. Like other resorts Mountain Lake was not without its tragedies: a disastrous train wreck occurred in 1902, and the Mountain Lake Hotel was struck and burned during a severe thunderstorm in August 1908. In those early days, there was no local fire department to fight fires. The proprietor and his wife got the hotel guests out safely, and the rain kept the fire from spreading.

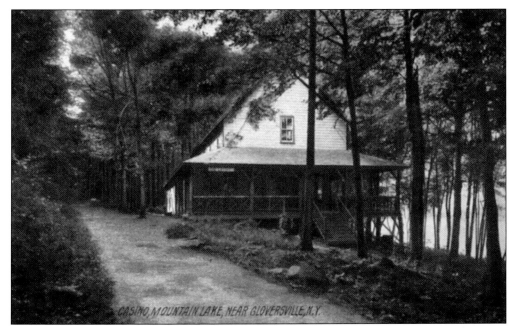

Laws against gambling were not enforced in the early days in the Adirondacks, and casinos were a major attraction. Games of chance, entertainment, and a shooting gallery were popular pastimes at Mountain Lake.

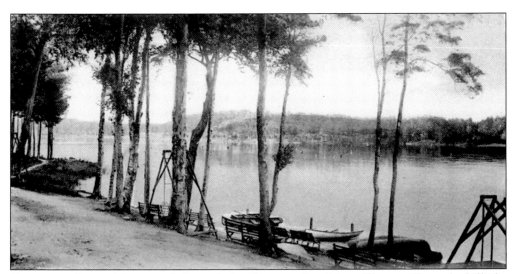

Guests traveling to Mountain Lake took the electric railroad from Gloversville up the hillside. In 1902, a wreck on that trolley line killed 13 passengers and hurt several others. (See *The Adirondacks 1830–1930*, by Donald R. Williams, page 17, and *Along the Adirondack Trail*, by Donald R. Williams, page 24.)

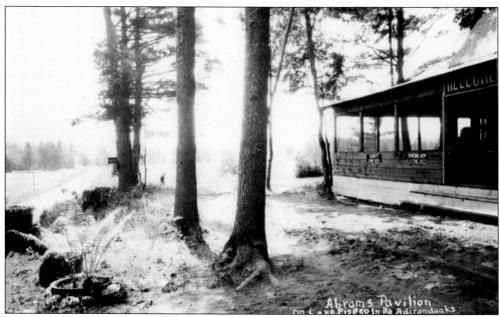

Abrams Amusement Park, with its Sawdust Dance Hall and Pavilion, opened in May 1928 in Piseco. Owner William Abrams added a baseball field and a clay-pigeon shooting trap house. A beach, a lighted picnic area, rental cabins, and a big tent provided accommodations for groups. Abrams operated one of the first airplane services in the area, and planes could use his landing field airway.

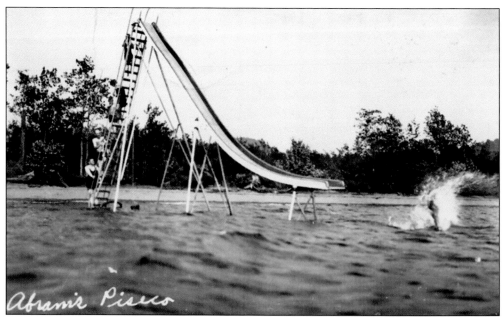

Abrams Amusement Park had a high water slide and the merry-go-round from Sacandaga Park. William Abrams once worked at Sacandaga Park, and when the Sacandaga dam was built and the park was flooded, he bought the merry-go-round, which remained a prime attraction at his park until 1950. The merry-go-round is now at the Shelburne Museum in Vermont.

NASCAR automobile racing came to the Adirondacks in 1952 with the forming of the Warrensburg Auto Racing Association. The association promoted the racing of stock cars at the old Warrensburg Fair Grounds. "Smiling" Les Hillis was the starter, and announcer Bob Jennings emceed the races. The old fairgrounds once offered an annual fair, with ribbons and awards for the best produce and livestock, and a midway with games of chance, exhibits, and rides.

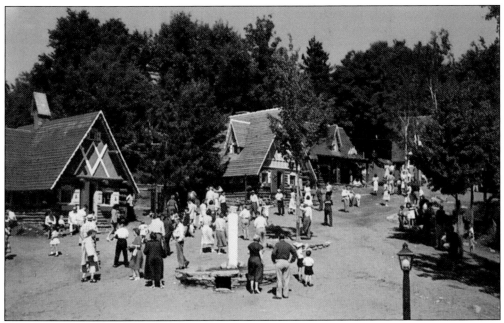

At the foot of Whiteface Mountain is the oldest theme park in the United States: Santa's Workshop, North Pole, New York. It was founded by Julian Reiss in 1948 and developed by toymaker-cartoonist Arto Monaco. Adirondack hermit Noah Rondeau once served as the bearded old gentleman. Santa's Workshop has its own post office and Mother Hubbard's Cupboard Restaurant.

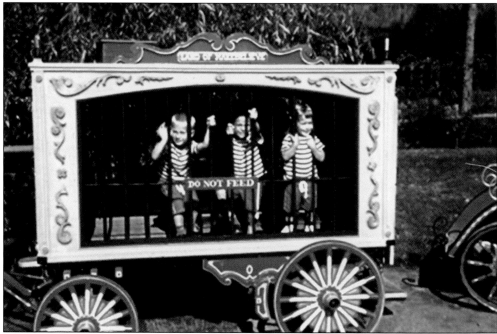

In 1954, Arto Monaco opened the Land of Make Believe in Upper Jay. Based on Aesop's fables and Mother Goose rhymes, it had a stagecoach, fire truck, calliope, and side-wheeler. Built on the flood plain of the Ausable River, it closed in 1979, after 13 floods.

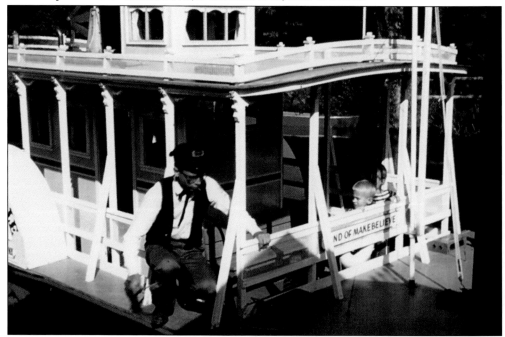

A miniature side-wheeler, the 22-foot-long *Billabong Belle* at the Land of Make Believe, was created to resemble a Mississippi River boat. Arto Monaco wanted his young visitors to experience the actual ride on the water. He also offered rides on a scaled live-steam train and in a pony-drawn coach.

For 25 years, the owners of the Land of Make Believe contended with the flooding of the Ausable River before being forced to close in 1979. Some of the buildings that remain on the site have caught the attention of architectural preservationists. Efforts to preserve the historic buildings are under way, and studies of their construction and a photographic record have been completed.

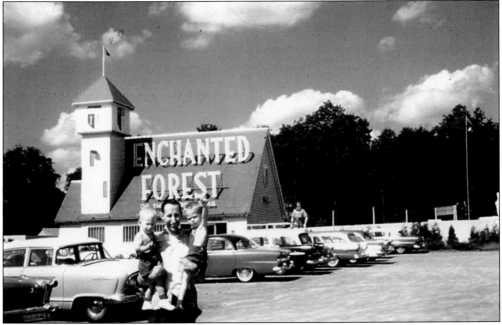

Enchanted Forest at Old Forge is home to Paul Bunyan, Ali Baba, Little Red Riding Hood, Snow White, and other storybook characters out of the past. With two 360-foot-long fiberglass water flumes and a water safari, Enchanted Forest is one of New York's largest water theme parks. Rides and attractions total 44, with 32 of them water rides.

Enchanted Forest celebrated its 50th anniversary in 2005. It features the enchanted princess, gold mines, Sleeping Beauty's Castle, Ali Baba's Cave, the Trail of the Yukon, and the Pirate Ship. It has old favorites like Alice, the Three Bears, and Humpty Dumpty and new favorites like Moon Walk and the Scrambler.

Rex the high-diving horse performed at the Magic Forest near Lake George for over 40 years. This park has a midway, 16 rides, bird shows, a safari trail, and a fairyland. The giant Uncle Sam still stands at the roadside of Route 9, inviting the visitors into the park.

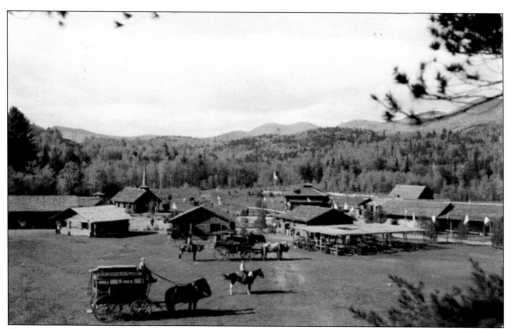

Frontier Town was a pioneer-settlement theme park that Arthur Bensen opened in 1952 off Adirondack Northway Exit 29 near Hudson. It published its own newspaper, the *Frontier Town Gazette*, with stories of the Dalton Boys, Doc Sawbones, Maw Daisy, Sheriff Carl Grant, Panhandle Pete, and others from the frontier days. The park closed in the early 1990s.

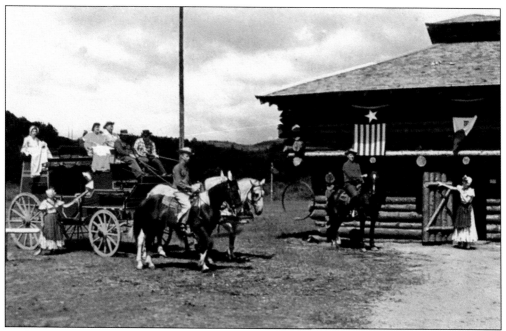

Arthur Bensen collected old-time equipment for Frontier Town. He found antique Concord stagecoaches and old animal treadmills. The park offered a rodeo, an industrial village named Roth's Forge, a Native American village, and a farm with live animals. Rides were given on a steam train and on the stagecoaches.

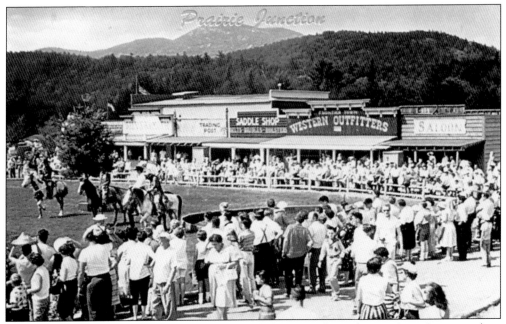

Visitors to Frontier Town could help the U.S. marshal capture the outlaws and watch a greased-pig chase. Employing some 300, the park fell on hard times, went through a series of owners, and closed in 1985. It was sold in 1988 for $1.3 million to a New Jersey water park owner who ran it for a short time. The 267-acre park was later sold at auction.

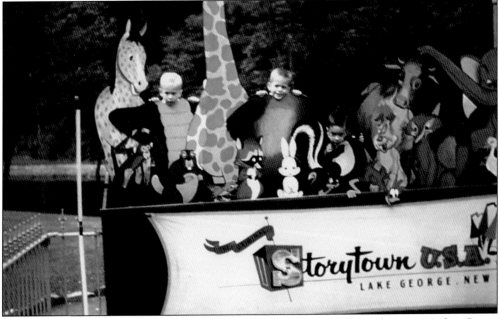

Storytown U.S.A., near Lake George, celebrated its 50th year in 2004. It features Mother Goose Land, 35 rides, and an international village. In 1969, the Little Church at Storytown was the site of a public little people wedding uniting Ruth Jenzer of Switzerland and Fred Souzek. A five-theme park, Storytown U.S.A. became the Great Escape in 1982 and the Great Escape and Splashwater Kingdom in 1995, and an indoor water park was added in 2006.

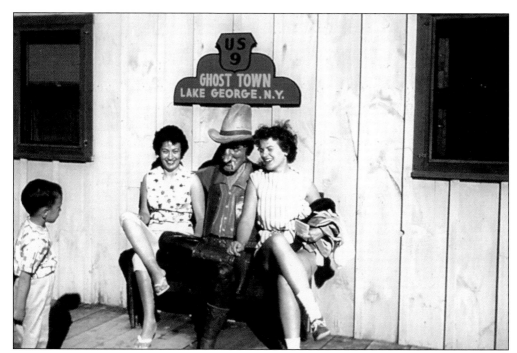

Ghost Town was part of Storytown U.S.A. in 1957. The facts and fictions of the gold rush days were recreated in an 1800 mining town. With authentic furnishings, it came close to the real thing.

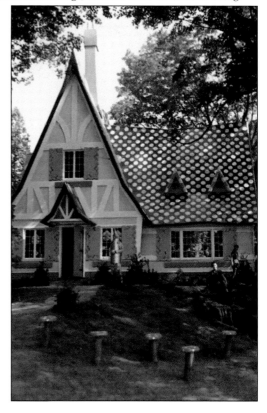

Fantasy Kingdom, on Lake Champlain near Plattsburgh, was created by Norman Dane Sr. It was built on lands owned by Dane's partner, Robert Duley, and the Castle of the Giants (pictured) was an entrance gateway. It also had a candy house; a Santa Claus House; Easter Bunny House; Peter, Peter Pumpkin Eater House; the Old Woman in the Shoe; and the Three Pigs House. The performance stage was a huge man-made tree stump.

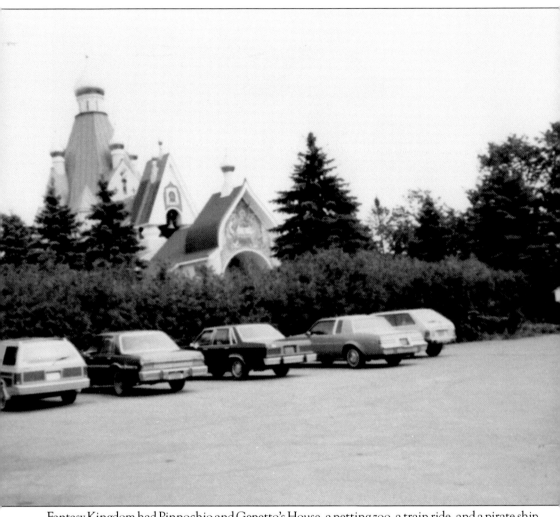

Fantasy Kingdom had Pinnochio and Gepetto's House, a petting zoo, a train ride, and a pirate ship, the *Jolly Roger*, which once sailed on a Lake Champlain bay. Unfortunately, the ship capsized in a storm. The park, located off the main highway, closed after just six seasons. Vandals destroyed the vacant buildings, and today the site is part of a picnic area and children's playground.

Three

AIRWAYS, RAILWAYS, ROADWAYS

Seaplanes have been a part of Adirondack history since at least the 1890s, when pilots flew in to preach at the lumber camps. Every fair-size lake could become a runway for floatplanes, providing the mountain downdrafts allowed for safe landing. Among the seaplane operators continuing that tradition today are Helms, Bird, and Payne. Landing fields have been developed at Piseco, Saranac Lake, Edinburgh, and Keene Valley. In addition, Caroga Lake had a runway on property that later became the Nick Stoner Municipal Golf Course, and both Sacandaga Park and Cranberry Creek had airstrips at one time.

One pilot found the Adirondacks unfriendly toward his runway. Jello heir Donald Woodward purchased land near Northville in Giffords Valley, dammed up the waters running through the property, and created a lake for the landing of floatplanes. But when pilots began to land, they found that the downdraft from the surrounding mountains made the process dangerous. Woodward ended up selling his venture.

Constructing tracks for trains through Adirondack country was a major feat. It took determined railroad barons, ambitious workers, and financial capital. The first railroad to arrive was the Saratoga-North Creek line in 1871. The Delaware and Hudson Railroad began coming through on its way to Canada in 1875. And the Chateaugay line from Plattsburgh to Saranac Lake opened in 1877. By 1891, trains went north from Utica to Saranac Lake and Lake Placid.

Eventually passengers could board trains in the big cities and make the sometimes 12-hour trip to Raquette Lake or North Creek. Major rail lines were developed from Utica to Lake Placid and from New York City to Montreal. Minor connecting links ventured to Raquette Lake, Tahawus, and Saranac Lake.

One important link for those from New York City and the south was the New York Central to Fonda. The Northville branch of the Fonda, Johnstown and Gloversville Railroad took passengers to the terminus at Northville, where stagecoaches awaited to transport passengers into Northville or north into the wilderness resorts.

Today's paved highways evolved from the footpaths of Native Americans and pioneers. The road from Malone to Tupper Lake was surveyed in the 1850s. The one from Lake Pleasant to Long Lake was laid out in 1855. And that from Northville to Lake Pleasant followed in 1858. The first macadam roads appeared around 1910.

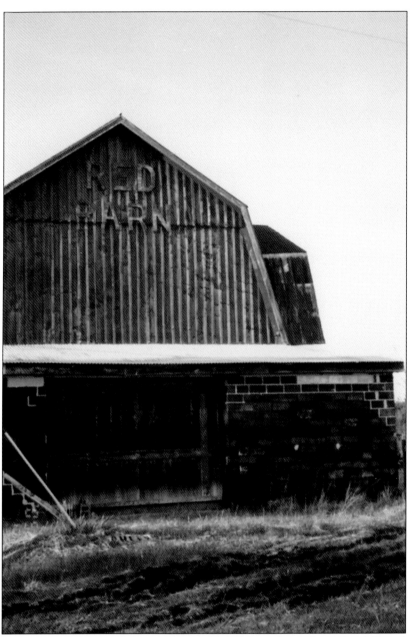

The Red Barn Airport sign is fading away on the old barn located on the Adirondack Trail (Route 30) between Northville and Mayfield. The airway, once a thriving venture, has also faded away. At one time, the airport offered a para-center where skydiving was available. Anyone from 16 to 70 could take the three-hour training course and then jump from the plane at 2,800 feet. Skydivers were assured that they would "be amazed and thrilled at the soft opening, beautiful view, and serenity" as they looked up at their opening parachute overhead. The local airways in the Adirondacks not only serve the Adirondacks but also fly passengers in and out of the area. Vacationers who have planes often use the airstrips for stopovers on longer trips. Some are kept plowed in the wintertime but not sanded so that pilots land at their own risk. Air shows, always a popular event, are often scheduled for entertainment and attract large crowds.

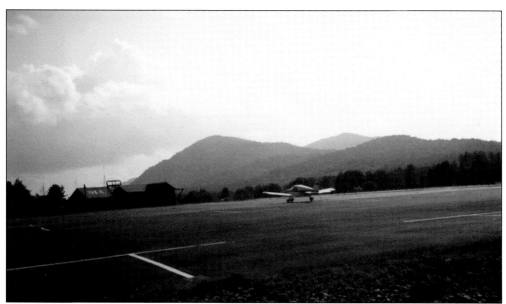

The Piseco Airport, nestled in the mountains at Arietta, is located in Hamilton County, where an annual fly-in especially for seaplanes has been held for over 30 years. The fly-in was first sponsored by Camp-of-the-Woods, a religious camp on Lake Pleasant and is now sponsored by the chamber of commerce, Department of Environmental Conservation, and local government. Planes fly into the Adirondacks from 25 states for the event where seminars and contests are held for the pilots. The event illustrates the interest in flying that has been a part of the Adirondacks from the beginning of settlements. Some permanent and seasonal residents of the Piseco area had airplanes in the 1930s and wanted a place to land near their homes or camps. They constructed a small airport on William Dunham's land. When he passed away in 1940, 40 residents petitioned the town of Arietta to buy the landing field and building for up to $11,000. It took some doing to get it on the ballot, and the way was cleared for a vote in 1950. It was passed with a 50–27 vote of the people. The airway venture became a final reality in 1960 after all the red tape was overcome.

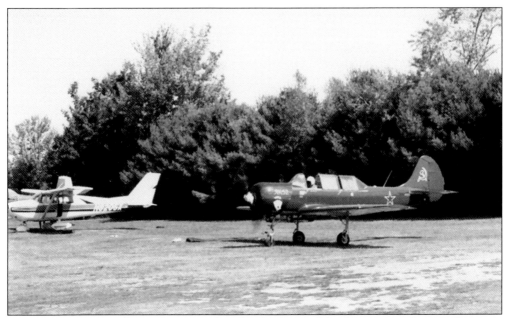

Back in 1948, Northville was boasting that they had one of the finest privately owned airports in New York State. It was conceived, developed, and owned by Victor Brownell. Plateau Sky Ranch is located at Edinburgh on the only plateau in the Great Sacandaga Lake region. The airport had three hard dirt runways when it was built, and flying service was supplied by the Adirondack Aero Club. The Civil Air Patrol and Northville businessman Lt. Walker LaRowe landed a World War II B-24 bomber on the strip in the 1940s. When it landed, the heavy craft dug two trenches in the soft ground. It could not take off from the field, so it was dismantled and trucked away. The plane was on display for an extended period of time, and visitors were allowed to go inside, sit in the cockpit, and tour the plane. It was a thrilling venture for the young men of Northville. Today the airway is used by several private plane owners. Those shown here include a Russian-made plane and a small private craft with U.S. Coast Guard printed on it.

The Delaware and Hudson Railroad specialized in getting visitors to the Adirondack region. Their advertising told of forest trails and streams, good hotels and clubs, and golf and tennis, along with lovely lakes. They promoted Lake George and Lake Placid and published booklets *The Summer Paradise in Pictures* and *The Summer Paradise in History* with photographs and stories from the Adirondack region. The Delaware and Hudson lines ran from Albany to Canada with spurs going off in several directions in the Adirondacks. The Delaware and Hudson got its start as a canal company in 1823, and by 1829, it was venturing in railroads.

Traveling by railway, as evidenced by this 1906 photograph, was easier than by horse or automobile. The tracks on the Northville branch of the Fonda, Johnstown and Gloversville Railroad were cleared of snow so the train could reach the Northville terminus. The train carried passengers through Mayfield, Cranberry Creek, and Sacandaga Park on the trip to the Northville station. Many of the big-game hunters from the capital district and Mohawk Valley used the train to reach the hunting grounds of the Adirondacks.

The Upper Hudson River Railroad was built at the end of the Civil War by Dr. Thomas Durant, who built the Union Pacific Railroad across the country. The original terminus was at North Creek, and during World War II, it was extended to the iron mines at Tahawus. Closed in 1989, it has been reopened from the North Creek Station, the site of Teddy Roosevelt's ride to the presidency, to the Riverside Station at Riparius. Additional restored tracks are now being added to further rehabilitate the historic railway.

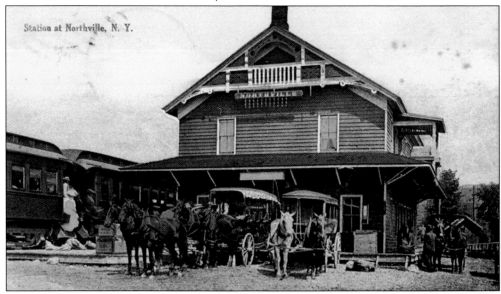

The terminus of the Fonda, Johnstown and Gloversville Railroad at Northville was across the Sacandaga River from the village. Horses and stages met the trains to take passengers across the bridge to the Northville hotels. The stage also took passengers north to their destinations in the Adirondacks. A stage made the trip to Wells and Speculator on a regular basis. The Northville line, connecting to the Fonda, Johnstown and Gloversville Railroad at Gloversville, got started by the Gloversville–Northville Railroad Company in 1875. By 1881, some financial difficulties led to a takeover by the Fonda, Johnstown and Gloversville Railroad.

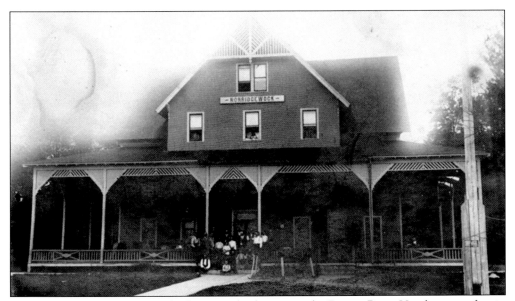

The Norridgewock, "home of the beaver," also known as the Beaver River Hotel, met its fate in 1907 when it burned to the ground. The original hotel was on the Mohawk and Malone Railroad, which was the only way to reach it on land. Dr. William Seward Webb built the Adirondack and St. Lawrence Railroad in 1891–1892 and later consolidated it into the Mohawk and Malone Railroad before selling it to the New York Central Railroad. Beaver River has no access roads through the "forever wild" Adirondacks; they depend on boats, snowmobiles, floatplanes, and railroad vehicles to avoid the 10-mile hike in to the remote hamlet.

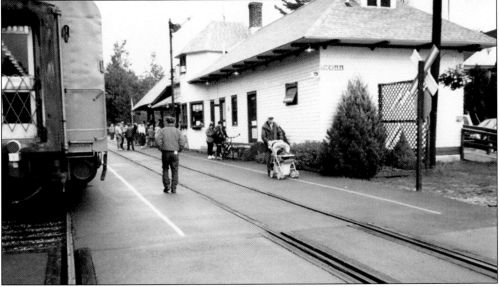

The Adirondack Scenic Railroad ventured on the Adirondack scene in 1891–1892, when Webb built his railway through the mountains. Abandoned over the years, it has now been reopened with excursion trains running on the rail line from Utica to Thendara/Old Forge in the Adirondacks. Other excursions run from Thendara on a 20-mile round trip into the Adirondacks and also from Lake Placid to Saranac Lake. The entire railway from Utica to Lake Placid is being restored.

The Adirondack landscape has changed in the past 100 years. Some of the roadways and waterways have been abandoned, and others have evolved into modern highways. The intense logging of the 1800s and the first half of the 1900s cleared much of the Adirondack forest. Early farmers also cleared hundreds of acres for pasture and farming. The Indian Lake clearing and the dirt roadway shown here have now been reclaimed by the forest, with some used by the Cedar River Golf Course and the new paved roadway. The pond, once held back by a dam, has now returned to its original bed. Note the lack of power lines in the days before electricity. Old stonewalls from the early clearings can be found in the Adirondack woods today along with the

apple trees and lilac bushes that once grew in the farmyard. Indian Lake is on the Adirondack Trail and was once reached only by pathways through the woods. Back in 1767, Abenaki Indian Sabael Benedict left Quebec, canoed down Lake Champlain, and entered the Adirondack wilds in search of game. His hike took him to two small lakes, which later became Indian Lake, surrounded by mountains. Other settlers came, some to hunt and fish, and lumbering developed as the major industry. A store, which still stands in Indian Lake Village, was built in 1877. Hotels followed to meet the needs of those traveling the Indian Lake roadways and, in 1898, the lake was dammed up to create a bigger lake and to supply water.

Much of the roadway work in the Adirondacks had to be done with manual labor. The heavy equipment of today was unknown. When storms broke out and brought down branches and trees, which blocked the roadway, men with axes and crosscut saws did the clearing. In the wintertime, landowners were responsible for keeping sections of the road cleared of deep snow and drifts. Most of the dirt roadways were not covered with macadam until after 1905.

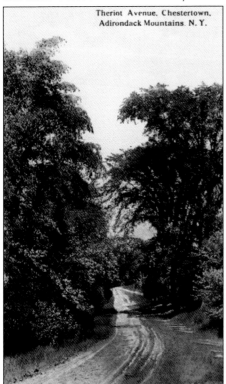

Theriot Avenue is the name of the street in this 1913 photograph. It does not look like the avenues of today; it is a narrow dirt pathway that appears just wide enough for a horse-drawn buckboard or wagon. The scene, with the surrounding forest and trees close to the road, is in Chestertown. The highways and streets of today have come a long way in the past 100 years, and people often take them for granted.

The notation on the photograph shown here was "back road." The highways of today evolved from these single-lane, two-track roadways made by the horses and wagons and stage coaches that preceded the automobile. There are still some of the old back roads left in the Adirondacks where, upon meeting someone coming from the opposite direction, it is necessary to pull off to the side to let them through. The roadways that were under-used and not kept open are returning to the wilderness. Some still appear on the old maps but cannot be found in the thick-growing woodlands.

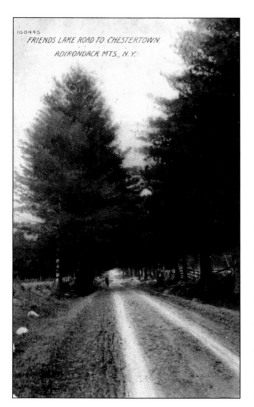

The wagon tracks on the roadway from Friends Lake to Chestertown in the 1910 photograph indicate that it is a one-way road. When the early stages or wagons met each other, one usually pulled off to the side to allow passage. When automobiles began to use the unpaved roadways, it became evident that new highways were needed. The noise and size of the invading automobiles often frightened the horses and caused runaways. Some believed that the troublesome automobiles would never replace the horses.

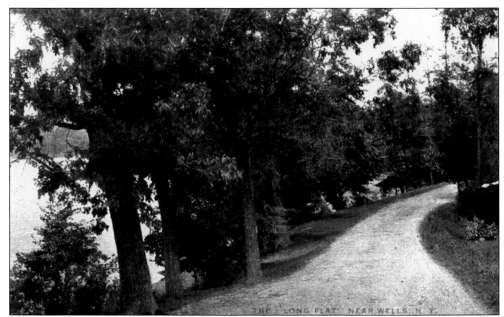

Narrow dirt roadways followed the shorelines of the Adirondack rivers and streams. Many were also following an original woodland pathway used by Native Americans and the early trappers and hunters before the Adirondack settlers moved in. Settlements grew up at the intersections of the early pathways, and eventually the governmental centers were established on the easiest reachable settlements. The roadways helped to determine where the people lived in the wilderness.

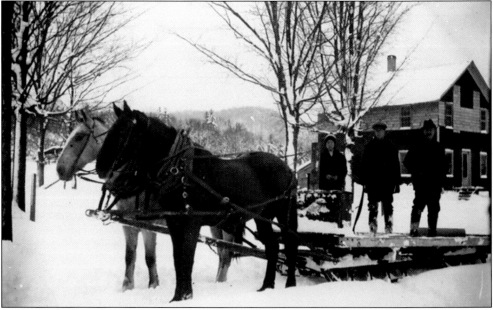

The winter roadways in the Adirondacks were kept covered with snow and ice so that the horse-drawn sleds could be used for transportation. When horses got down in the drifts or fell on the slippery ice, it was a major task to get the harnesses off, get the horses back up, and then reharness them. In this 1913 photograph, the roadway is snow covered, indicating that not enough of the new automobiles were in use at that time to pay for plowing the roads clear.

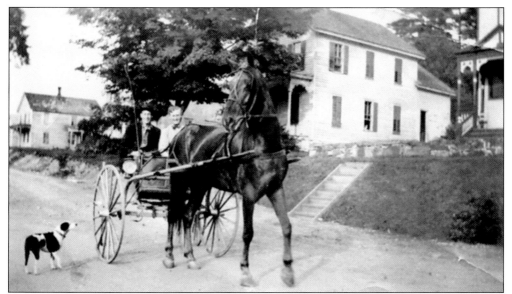

Going out for a Sunday drive at the beginning of the 20th century meant hitching up the horse to the wagon, pulling on the reins, and watching out for a loose dog or other distraction that might spook the horses. Or one might want to take the dog for a ride much like the young lady in the photograph. Keeping a horse for transportation was not as easy as one might think. The horse had to be fed and watered on a regular basis, which meant securing hay and grain and maintaining a year-round water source. The horse needed to be rubbed down and brushed after the work of pulling the wagon, and the hooves had to be kept clear of stones, mud, and ice. Horse-trading became a major business, and stories of getting cheated in a horse trade entered the Adirondack picture. One trader maintained that the reason the horse's ribs showed was because he fed him so much food it was pushing them out.

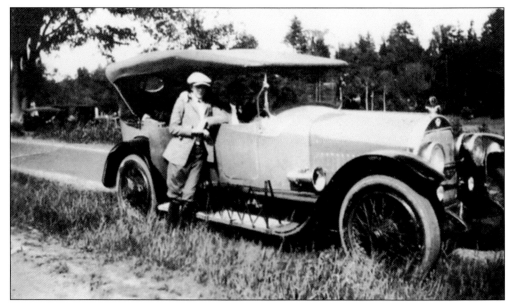

Once the Adirondack roadways became hardtop roads, touring became an American pastime. Large touring cars came on the scene, and tourists could ride in style. Trips were taken on the Adirondack roadways that were called "around the horn," whereby the tour made a big circle through the mountains and back to the point of origin. One of the earliest automobiles used in the Adirondacks was the 1908 red Waltham Orient Buckboard, a vehicle made of wood.

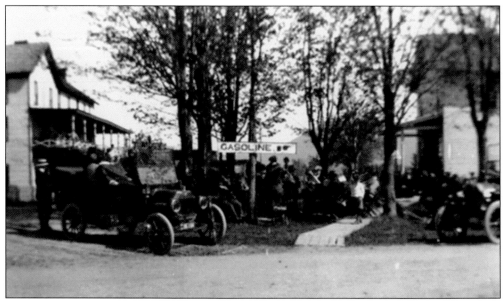

The tourists have driven their new touring automobiles to a band concert in Speculator. Gasoline, note the sign, was made available so that the cars could fill up to make the return trip without running out of fuel. Note that the roadway is still a dirt road and the sidewalks are made of planks. Once the need for roadways became evident, licensing became a way of life for car owners, although they opposed it. On November 5, 1917, an automobile parade was held in Northville in support of the no-license campaign.

Roadways for automobiles through the Adirondacks brought the need for service stations. Automobiles needed repairs, new tires, water, and gasoline to keep them moving. Self-taught mechanics opened up repair shops in old barns and other roadside buildings. One mechanic became so good at making new car parts on his lathe that it was said, "If Oliver can't make the part, throw the car away!"

Route 9 became the major north–south roadway in the Adirondacks once the automobile came into widespread use. By the 1930s, the garages, gas stations, and roadside restaurants came along with the automobile. The building on the left is Pierson's Garage, managed by Ross Williams, supplying gasoline, towing, and repairs at Loon Lake on Route 9. The building on the shoreline is the Pierson Brothers' Restaurant and Recreation Pier, a popular stopping-off place on the road from New York to Montreal.

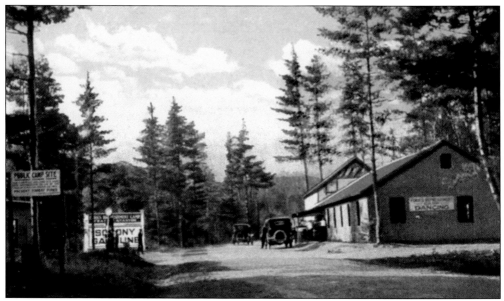

Back in the 1920s, roadside stop-offs for the growing automobile traffic became important. On the Adirondack Trail (Route 30), the roadway ran through the Public Auto Campsite, one of the first state camping grounds, on the Sacandaga River. A business, which included a gas station, store, and dance pavilion, was added. Frank Stanyon owned it for many years and made it a popular dance hall for the southern Adirondacks. It was known as the Forks, a name derived from the branches of the river that met at that location.

Those who enjoyed touring the Adirondack roadways in the early decades of the 20th century had a good choice of roadsters and other automobiles that were being developed for the traveling public. One option early car owners had was to change the body of the car if they wanted a different style or if the first had been damaged. The new car body in the replacement here has a roof that opens in, convertible style.

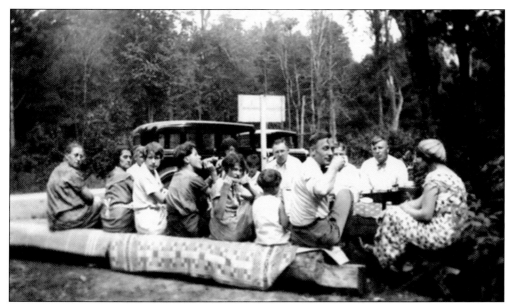

Roadside picnics became a part of the American scene as the Adirondack pathways became highways. Family outings and stops along the roadway led to the development of the state campsites and picnic grounds that are in widespread use in the Adirondacks today. Travel was much slower, and it was not uncommon to have the need to stop for meals on a trip and, on occasion, to spend the night in a tent or at a boardinghouse.

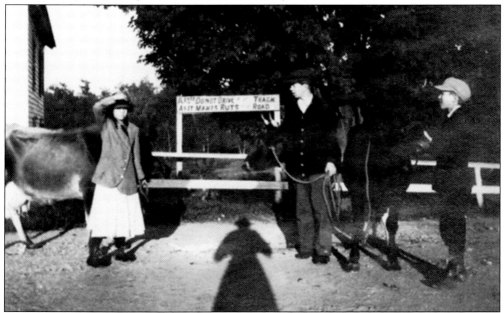

The sign reads, "Please do not drive on the track as it makes ruts in the road." Each well-dressed young person in the photograph is leading a cow on a rope. They are attending some kind of fair where the animals are paraded around the track and judged. It was a part of the rural way of life for the young people in the Adirondacks to be responsible for the raising of an animal. Earning a ribbon at the annual fair was a source of pride. Before roadways were paved, the automobiles often dug deep ruts in the dirt, especially in springtime.

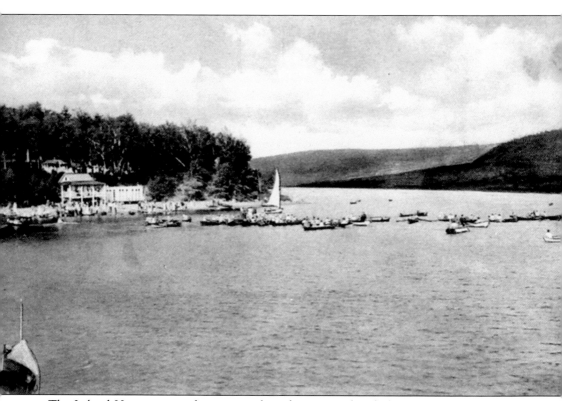

The Leland House attracted visitors and residents to its beach for some 78 years. Opened in 1872 on Schroon Lake by J. Monroe Leland and his sons William and C. Thurman, it became the place to stay. The Adirondack waterways became the main attraction in the Adirondacks when the giant hotels began to appear on their shores. A good beach, connected to a hotel with a good reputation, could count on attracting large numbers of guests if it also had good roadways leading to it. James Emerson, one of the later owners, sponsored legislation while he was a state senator to pave the roads for miles around where muddy wagon trails had been the only roadways. Good resort business in the Adirondacks depended on good roadways to open up that region of the state for residents, camp owners, tourists, and all who wanted to enjoy the Adirondack ventures. The Leland House business grew, and additions were made to the hotel to accommodate 200 guests. It became a high-class hotel attracting the rich and famous. The Leland House had a long history similar to many Adirondack ventures; they suffered two major fires before eventually closing all parts of the business by 1950.

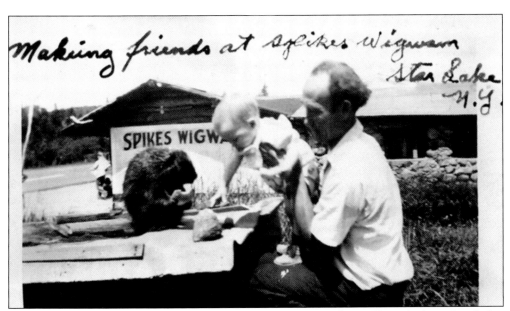

Roadside attractions sprang up across the Adirondacks once the traffic picked up. Star Lake, near the western border, had Spikes Wigwam. Often the wild animals at the attractions became somewhat tame, and visitors could pet them, a forerunner of petting zoos. The young child in the photograph seems to be enjoying a visit with an Adirondack beaver. At that time in Adirondack history, the beavers were scarce and had to be reintroduced.

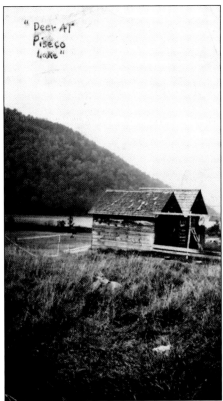

Roadside animal farms, large and small, could be found along the Adirondack roadways in the 20th century. The Adirondack white-tailed deer were the most popular, attracting the touring public both in captivity and in the wild. A close look reveals a deer in the grass at an enclosure at Piseco Lake in 1929. Henry Rogers of Lake Pleasant once had a tame deer that became an attraction.

Old McDonald had a farm, and it was found on a Lake Placid roadway. Visitors to the farm were met by farm maids in costume, and each visitor was given a straw hat to wear. A ride through the "picturesque quarter million dollar fairyland farm" was taken on an old-fashioned hay wagon. The outdoor picnic dinner included chicken and corn on the cob. Barn dances, farm animals, and trout fishing were all part of life at the farm.

Visitors could enjoy the 29 species of animals at the Alaska Silver Fox Farm, later named Sterling Alaska Fur and Game Farms, and could also purchase furs. In 1921, they advertised, "We sell furs from the animals back direct to yours." They guaranteed perfect skins at a 50 percent savings. Fox skins, Hudson Bay sables, mink, Alaska lynx, otter, bear, wolf, wolverine, and ermine furs were offered at the farm.

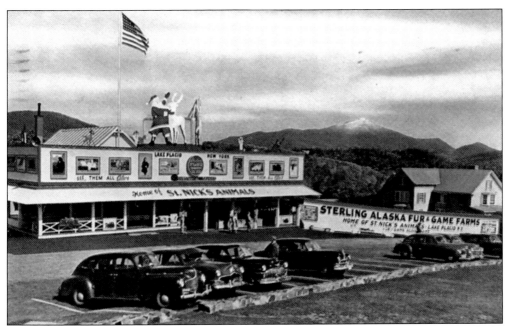

St. Nick's animals came to the Adirondacks in 1915. They could be found at the Sterling Alaska Fur and Game Farms. One farm was located at the Lake Placid roadway and the other at Ausable Chasm. A later farm was also opened at Plattsburgh. Visitors could enjoy seeing 1,000 animals and purchase "fine furs at producers prices." Among the 29 species of animals kept at the farms were mink, llamas, mountain sheep, four kinds of deer, goats, otters, bears, wolves, lynx, sable, and fox. The farm had the Sapphire Mink, the world's most valuable. Additional mink included Pastel, Breath-of-Spring, Silver-Blu, and Yukon-Dark. The "largest of their kind in the world," the animal farms were owned by Joseph S. Sterling. The 1,000 animals at the farms were advertised to be alive and tame.

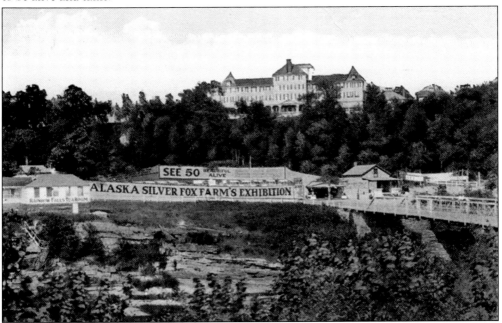

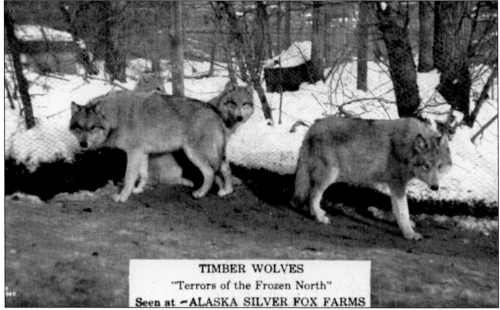

Some of the animals at the Sterling Alaska Fur and Game Farms were tame. Others were treated with caution; the timber wolves were called "Terrors of the Frozen North." Reportedly, some of the silver fox at the farms were worth $1,000. Mink fur could be purchased in six different colors. The once-popular farms are closed today.

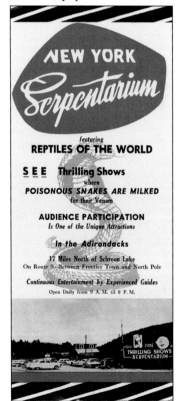

The New York Serpentarium, another short-lived roadside attraction, was located on Route 9 north of Schroon Lake. It featured reptiles of the world. Serpentarium guides stretched out the Regal Python from Asia and wrestled with the alligators. They exhibited the giant turtles, the oldest living creatures, and tropical lizards. The boa constrictors required special handling. And poisonous snakes were milked for their venom.

Four

FAIRWAYS, PARKWAYS, SKI WAYS

The game of golf found its way to America some 250 years ago. It originated in Scotland in the 1450s. Records show that some golf clubs were shipped to the American colonies in the early 1740s. Golf did not arrive in the Adirondacks, however, until the 1890s, with the influx of summer vacationers and wealthy camp owners.

Adirondack camp builder-developer William West Durant constructed a course at Eagle Nest near Blue Mountain Lake in 1899. The Fonda, Johnstown, and Gloversville Railroad Company developed "superb golf links" in connection with Sacandaga Park near Northville in 1898. At Wakely Lodge in Indian Lake and at Nick Stoner's in Caroga Lake, golfers faced the added challenges of trees and white-tailed deer.

Some of the vintage golf courses in the Adirondacks have returned to nature, and others are still open after some 100 years of use. Older or newer, a total of 32 Adirondack courses are open today.

Traditionally a roadway with a center grassy strip has been known as a parkway. Possibly the biggest parkway in the Adirondacks is the Adirondack Northway. Built in 1957, this four-lane route has won awards for being one of America's most scenic highways. Other less-well-known parkways are found in small towns and rural areas. The New York State campsite (park) on the Sacandaga River once had a parkway running through the grounds. There are also modified parkways—those with side roads to small settlements or lakeside drives that circle around and back.

The early ski ways were steep hills on which the skiers "herringboned" up with leg power and then skied down. Later, rope tows, powered by an old Model T automobile, provided a motorized ride up the hill. As interest in downhill skiing increased, a dozen ski centers opened. The Olympics mountain Whiteface offers the greatest vertical drop found in the East. Cross-country ski ways also were developed and are still being developed.

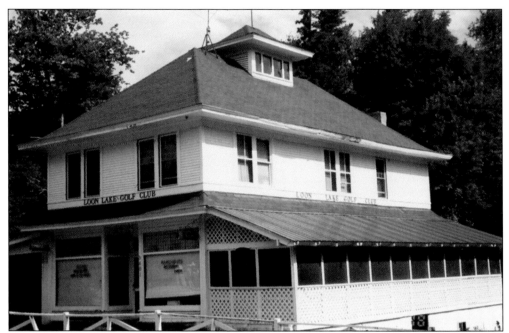

At the time of this writing, the Loon Lake Golf Club, once a thriving 18-hole historic golf course, was seeking new management. Closed for some two years, it is fast giving away to Mother Nature's growth. It was built in 1895 by Mary and Fred Chase, who also built the 500-guest hotel at Loon Lake in 1878. The hotel burned in 1956. The historic golf course was the first in the Adirondacks. The caddie house at the site, also built in 1895, stands out with its unique architectural design. Both the caddie house and the clubhouse shown here were designed by famed architect Sanford White.

The Thendara Golf Club offers an 18-hole course near Old Forge that is open to all. It is a par 72, 6,000-yards-plus, Donald Ross–designed course. The adjacent Moose River makes it an interesting course for the players who may want to travel to the course from Utica on the reopened Adirondack Scenic Railroad. The open fairways of the front combined with the narrow, tree-lined fairway on the inward nine provide a taste of golfing in an Adirondack setting.

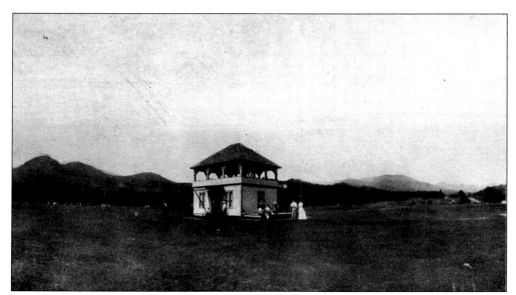

The fairways at the Cobble Hill Golf Course at Elizabethtown have been welcoming golfers since 1897. The nine-hole course offers a good view of Cobble Hill and the High Peaks of the Adirondacks to those who enjoy Adirondack golfing. Built for the Windsor Hotel, today the Cobble Hill course is the County Municipal Par-35 Course. A 1921 Adirondack guidebook called Cobble Hill "a golfers paradise" and "the golf links are admittedly one of the finest in the north." The "backbone" of this early golfing organization was described as the patrons of Deer's Head Inn and the Windsor, along with the large summer colony of cottagers. Golfers who use the Cobble Hill course enjoy golfing under the "majestic white pine trees." In the 1914 photograph (top), the clubhouse was open on the second floor, and the porch that can be observed in the later photograph had not been added to it.

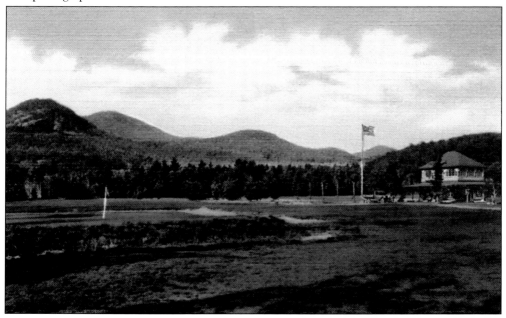

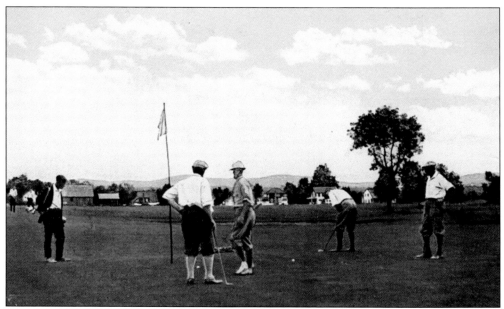

The Sacandaga Golf Course was one of the first 20 built in New York State. The first four holes were developed in 1898, and by 1903, it expanded to a nine-hole course. The Callaway scoring system was developed at the course in 1942 by Lionel R. Callaway. The Fonda, Johnstown and Gloversville Railroad developed the course as part of the creation of the Sacandaga Amusement Park, and it is one of the few remnants of the original park left today.

The original caddie shack still stands on the fairway at the Sacandaga Golf Course. In use for storage, it is being restored. The nine-hole course winds its way through tall pines, winding streams, and ravines, where the holes are well guarded by hazards and challenges. Over the years, it has been known as the "thinking" golfer's course.

Eagle Nest was once the home of dime-novel writer Edward Zane Carroll, known as Ned Buntline. In 1899, William West Durant, Adirondack developer, began blasting out an Adirondack golf course, which opened in 1900. The nine-hole course was designed by Willie Dun and was known as Eagle Nest Golf Course and Country Club. The club was incorporated with 100 members, went bankrupt in four years, sold out, and then was abandoned in 1928. This view was taken from an airplane at 4,500 feet. It shows Eagle Lake and Eagle Nest Club and Golf Course (foreground).

The Lake Pleasant Golf Course, with its rolling fairways, offers great Adirondack views to the golfers. The nine-hole course was built in 1922 for the patrons of the popular Hotel Morley. It is owned by a corporation today and serves golfers from the resort and populated areas of the southern Adirondacks. The Adirondack climate dictates its season from mid-April to mid-October.

The Nick Stoner Municipal Golf Course is now the official name of the 1925 golf course in the town of Caroga. In 1929, the statue of Nicholas Stoner—war hero and Adirondack guide—was dedicated and the name changed from Caroga Recreation Park. Golfers say they have to play and score carefully, as Nick Stoner on the hill is watching them.

The golf course in the town of Caroga was constructed in 1925 on lands donated by Cyrus Durey, a congressman who was born in Caroga. The first nine holes were constructed in 1925 and 1926, and the second nine were added in 1929. It became the oldest continuously operated 18-hole golf course in the Adirondacks.

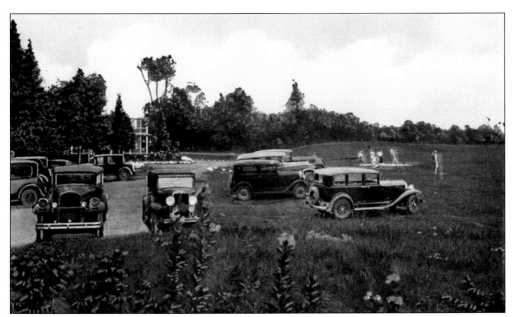

Inlet Golf Course, an 18-hole, par 72, 6,000-yards-plus challenge, has a long history. The immaculately groomed championship course is an Adirondack golfing treasure. Some say it is a perfect blend of nature and golf nestled among the mountains and lakes. It is known for its wooded setting among hardwood, spruce, and tamarack. The course was built in 1926 as a five-hole course, was later enlarged to 12 holes, and in 1989, made into a full-fledged 18 holes. Note the old automobiles. The automobile made it possible to open a successful golf course in the remote regions of the Adirondacks.

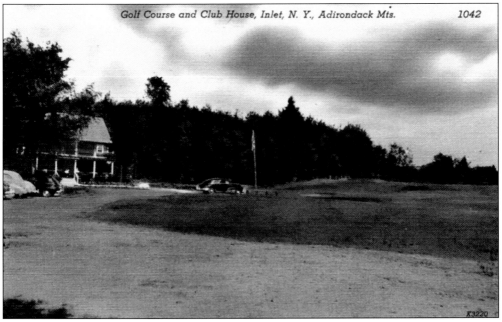

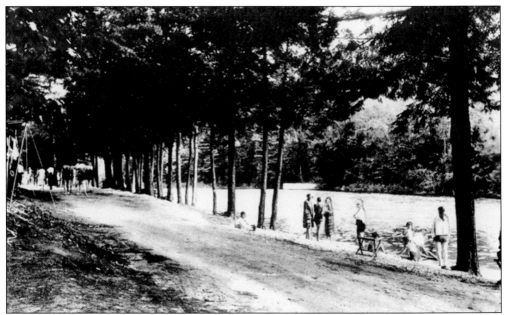

Adirondack parkways appeared in unique ways. Campers set up campsites along the Sacandaga roadway near Wells with canvas tents covered with wax to waterproof them. Platforms were placed under them to allow the water to go through. When automobiles came into use, the site evolved into the state-operated Sacandaga Campsite. For many years, the roadway ran through the camp, with individual sites for campers on each side of the road. A large bathing beach with bathhouses and a swimming area was created by a small dam on the river. The dam was taken out, ending the swimming area, and the parkway was closed to through traffic. The routine, followed by many of the local residents, of driving down the main road and turning up through the parkway back to Wells for an evening drive was ended when the barriers went up.

Building the roads around the Adirondack boulders and cliffs created a parkway effect throughout the mountainous country. The giant High Rock near Warrensburg is a good example of an Adirondack erratic. When the melting ice of the glacier left the Adirondacks, it dropped giant rocks off in an erratic way. Some were high on mountains, others along the lowlands. In some cases, they dropped one on top of another when the ice melted, creating a balancing rock.

The gateway on the pathway into Sacandaga Park invited visitors into the "Gem of the Adirondacks," the amusement park created by the Fonda, Johnstown and Gloversville Railroad in 1876. The park closed in 1930, when the creation of the Great Sacandaga Lake flooded much of the midway and other features of the resort. Today the gateway, somewhat overgrown, still stands in mute testimony of the once-major Adirondack attraction.

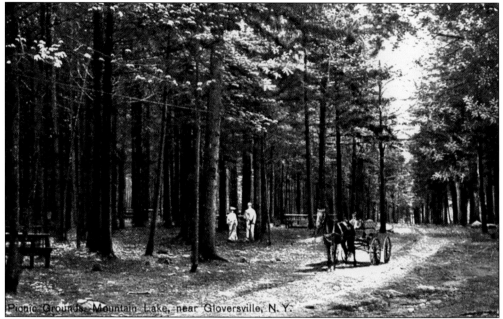

Picnics under the pines were popular at the Adirondack outdoor parks. Travel by horse and buggy preceded the days of the automobile and served to keep the general public attending the existing parks. Once the automobile came to the Adirondacks, the popularity waned for the small, local parks and many of them went out of business. Some turned into small seasonal settlements of summer camps.

Winter uses of the Adirondacks began to catch on, and the region became more than just a summer destination. Winter sports got an early start in Speculator with the 1900s Winter Sports Club. The first Winter Olympics had been held in France in 1924, and by 1927, the village joined the winter fun. A toboggan slide and a skating rink were opened, and a hockey rink was built for the hockey team. A ski tow, using a Ford Model A, was operated on Page Street. A new rope tow was purchased in 1934, and in 1947, was moved to the Oak Mountain ski way. Cross-country ski trails were added, and Speculator became a major center for winter sports, attracting champions and tourists from many other places.

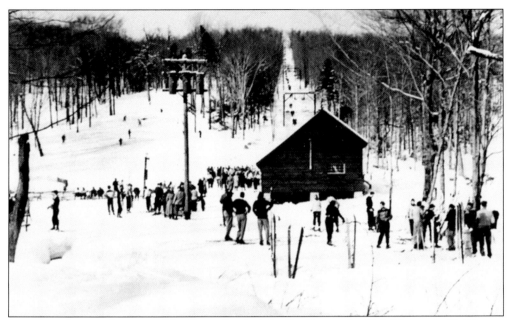

Speculator became known as "the Snow Bowl of the East" once the Oak Mountain Ski Center got in full operation. Snow came early and lasted long during the winter season. The Oak Mountain Center was owned by the town of Lake Pleasant and leased to operators for many years. In 1950, extensive improvements and a face lift made it a popular southern Adirondack ski way. Trails were drained and groomed, and the growing rock crop was removed. New T-bars were added to the 3,100-foot-long lift.

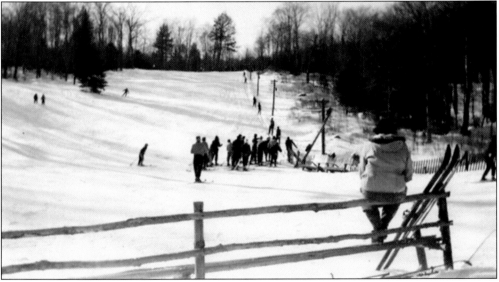

The Oak Mountain Ski Center opened in 1946 with seven downhill trails ranging from expert to novice. The ski way was owned and operated by the town of Lake Pleasant until 1967. It was put up for sale for $100,000, but no bidders came forth. The trails had Adirondack names such as Kunjamuk and Sacandaga. Today Oak Mountain offers 13 trails ranging from most difficult to novice. A new chairlift has been added, and a tubing area and lift adds a new dimension to the longtime ski center.

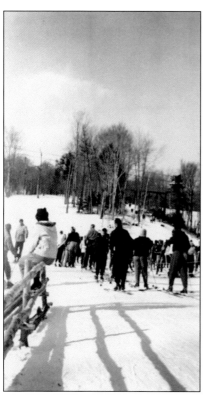

Kay Gifford had leased the ski way earlier, and the Novosel Enterprises had been leasing it when the town decided that a private owner could improve the offerings at the site with the addition of other attractions. Eventually the Novosel family purchased Oak Mountain Ski Center and continued to run it as a family ski way. Today's owners, Norman Germain and Nancy Germain (née Novosel), took over in 1979 and have added facilities for snow making and snowboarding and tubing, new lifts, a new road, parking lot improvements, and a new year-round lodge and restaurant.

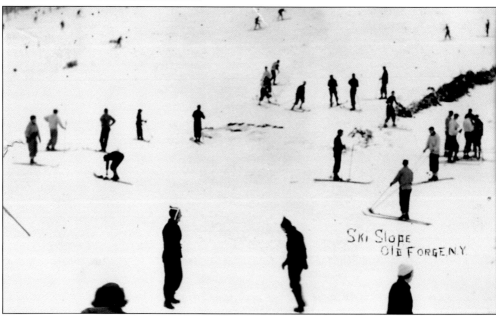

Once ski ways came to America, many of the Adirondack settlements found a nearby hillside ideal for skiing. Max Bolli, a skier from Switzerland, came to America in 1936 and saw the potential for making skiing a major sport. He moved to Old Forge in 1937 and helped to make skiing part of the school's physical education program. A rope tow was put on Maple Ridge Slope and classes began. Some of the early skiers went on to further accomplishments in skiing.

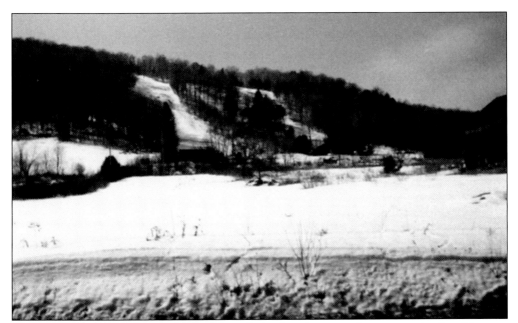

Royal Mountain in the southern Adirondacks has become the mountain for ski ways, snowboarding, and motorcycles. Some 20 years ago, James Blaise bought the ski center from Fred and Eleanor Saunder, who had run it for some 30 years. He developed it into a year-round operation with the addition of the motocross track, where championship races are held on a regular basis during the warm weather.

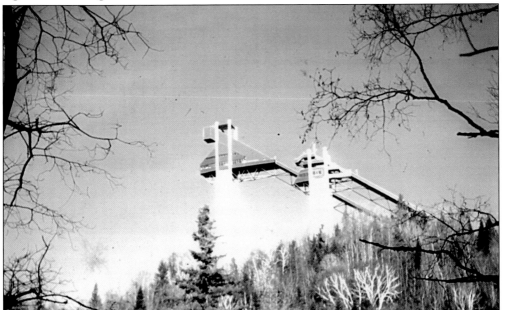

The MacKenzie-Intervale ski-jumping complex at Lake Placid was built for the 1980 Winter Olympics on the site of the 1921 Lake Placid Club ski jump. Today it serves to train jumpers from age five up on 15-, 25-, and 40-meter jumps. International competition is held for 70- and 90-meter jumps and aerial freestyle skiing. The public can take the glass-enclosed elevator to the top of the 26-story complex for a fabulous view of Adirondack country.

Whiteface Mountain is known today as the Olympic Mountain, another step in its interesting history. (See *The Adirondacks 1931–1990*, by Donald R. Williams, page 22.) The building of an eight-mile, paved memorial highway up the mountain was begun in 1931. The $1.25 million highway was dedicated in 1935 by Pres. Franklin D. Roosevelt as a memorial to soldiers killed in World War I. In 1985, it was rededicated by Gov. Mario O. Cuomo to the veterans of all wars.

This 424-foot-long tunnel in Whiteface Mountain leads to the elevator used to go 276 feet to the top. The view from New York's fifth highest mountain includes four states, two provinces, and 100 bodies of water. Arctic air sweeping down from the North Pole touches its first point of land on the peak, making it an ideal location for the Atmospheric Science Research Center.

Five

PATHWAYS, BIKEWAYS, BYWAYS

Pathways were the forerunners of today's roadways and highways. Native Americans, trappers, hunters, and soldiers followed the early trails to penetrate the mountains or to reach Canada. One of the earliest recorded episodes of the use of Adirondack pathways was Sir John Johnson's escape to Canada during the American Revolution. As early as 1780, Canada Island, in the Sacandaga River near Hope, marked a fork in the pathway to Canada. Some pathways followed old log roads, and some have evolved into today's Adirondack hiking trails.

Bikeways were part of the Adirondacks when automobile traffic was seldom heavy on the roadways. Bicycles were used by those in the rural areas to get to town, and they were used around town to get from one place to another. Bike racks at the local schools were always filled with bicycles when school was in session. Bicycle races have been held in the Adirondack communities, and some of the highways have been marked with a bicycle lane. Mountain bikes can be found on the woodland trails today.

Byways are those routes that have something special about them. Most, if not all, states have a Scenic Byway program. New York State's program, established in 1992, is overseen by the State Scenic Byway Advisory Board and managed by the Department of Transportation Landscape Architect Bureau.

Adirondack byways include the Adirondack Trail, a north–south route through the center of the Adirondacks; the Black River Trail; the Central Adirondack Trail, the east–west route from Glens Falls to Rome; the Colonial Trail; the Champlain Trail, in honor of Samuel De Champlain, one of the first white men to visit the mountains; the Dude Ranch Trail; the Military Trail; the Olympic Trail, in honor of the 1932 and 1980 Winter Olympics at Lake Placid; and Roosevelt-Marcy Trail, a tribute to Pres. Theodore Roosevelt, who became president while vacationing in the Adirondacks.

Snowshoes stand in wait for those who want to follow a winter pathway on the snow. The modified bear paw snowshoes shown here, made by Richard Havlick of Mayfield, follow a long tradition in the Adirondacks. Some evidence indicates that they were used by the Native Americans and the early spruce gum pickers. Adirondack hunters and trappers and those who worked in the winter woods needed snowshoes to walk the deep Adirondack snows. Sap gatherers in the maple sugar bushes made good use of snowshoes in the soft springtime snow.

There are pathways in the Adirondacks that are lined with those giant virgin white pine trees that were growing there when man first found the mountains. Some 20 feet in circumference, they reach to the sky. Pine Orchard, near Wells, continues to attract the hikers who seek out the giant trees. During the big "Blowdown" in 1950, only three of these giant blown-down logs could be taken out on a truck at the same time.

Special pathways were needed in the Adirondacks to get across the streams and rivers into the backcountry. Solutions included cable bridges, boats, and cables. The cable shown here was across Hamilton Stream. Most cables are gone today in keeping with the "forever wild" provision of the New York State Constitution; they were a nonconforming use. The old trail guidebooks recommended calling across the West Branch of the Sacandaga River to get a boat to come across.

The giant outcropping of sandstone reaches for the clouds on the top of Chimney Mountain near Indian Lake. The mile-and-a-half pathway up the mountain is somewhat steep but a popular hike for young and old alike. The view from the top and the presence of crevices and caves make the assent worthwhile. At times, the Adirondack mountaintops are covered by clouds, causing one young hiker to exclaim, "My teacher says I always have my head in the clouds, and today it's true."

Early pathways in the Adirondacks evolved into trails, other trails were added, and today there are an untold number of miles of trails for hikers in the Adirondacks. Trailheads have registers for hikers to sign in and out in case of someone getting off the trail and lost. Most trails are kept in good condition and can be traversed by young and old. Trails are marked with colored trail markers using blue for the major trails. Most of the Adirondack peaks have trails to the top.

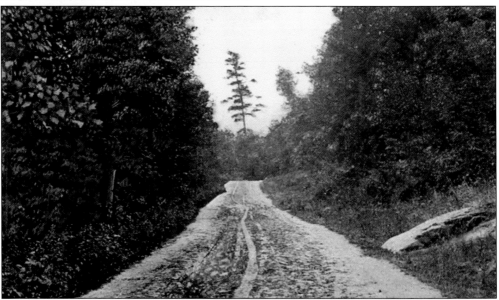

The pathway shown here has a caption, "The Trail of the Lonesome Pine-5th-6th Lake Carry-Adirondacks." Portages in the Adirondacks are called carries; the Adirondack guides carried the guide boats and gear between the waterways. At one time, water transportation was the choice means of traveling through the forested mountains; roadways were undeveloped or nonexistent in the wilderness.

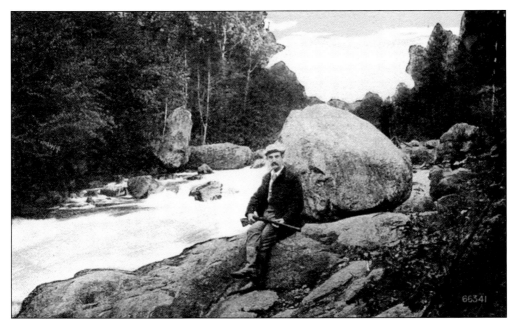

The title on this photograph is *On the Runway in the Adirondack Mountains*. When deer hunting became a tradition in the Adirondacks, the hunters found the runways, the pathways used by the deer in their wanderings for food, shelter, and water. The well-dressed hunter was from the city and was referred to as a "sport" in the Adirondack hunting camps.

Taking the sheep to pasture up an Adirondack pathway was a job for children. The raising of sheep was once a major occupation in the Adirondack country. As early as 1845, the census listed 2,644 sheep in Hamilton County. Essex County had 90,500 sheep, and nine other Adirondack counties had 974,250 sheep. That is a lot of sheep in the wooded Adirondack region, but wool was needed for family use and to sell for cash money.

One of the most-used pathways in the Adirondacks of yesteryear was the pathway up the hill above Sacandaga Park. The pathway led to a huge rock, one of those glacial erratics left when the ice receded. The view of the Sacandaga Valley from "high rock" was spectacular. High Rock Lodge was erected on the hill in 1901 by James Hall of Gloversville. It reportedly was built for innkeeper R. D. Buckingham. W. Ashley and Mildred Dawes bought the lodge in 1939 and added several cottages to the 150-guest hostelry. The lodge featured Thursday evening steak roasts and Sunday evening buffets. Horseback riding was available, and bridle pathways helped visitors to safely enjoy the Adirondacks. The main lodge building was destroyed by fire in August 1951, and a smaller building continued to house the guests. Many celebrities connected with the Sacandaga Summer Theatre stayed at High Rock. Today the property is privately owned, and the pathway to High Rock is no more.

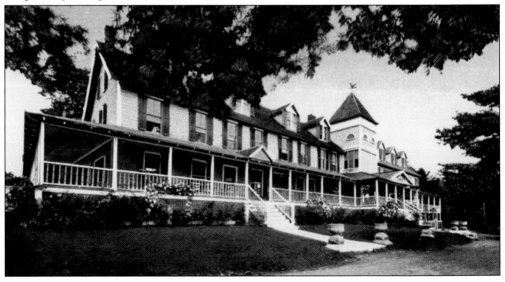

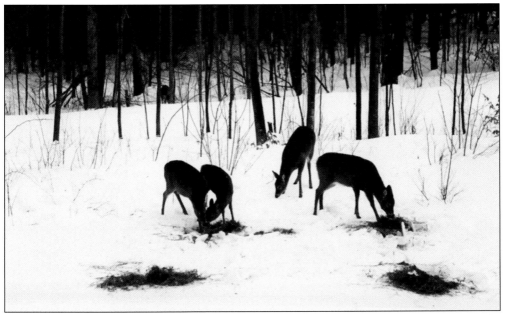

The Adirondack white-tailed deer created their own winter pathways to the deer feeding yards. The deer naturally yard-up in the evergreen stands during the cold weather to keep out of the wind and to search for browse. In bad winters, it was common practice for many Adirondackers to feed the deer to help them survive the snowy season. Today it is illegal to feed the deer; the deer are left to what comes naturally.

A 1790 geography book describes the Adirondack stone bridge and caves at Pottersville. Once bounty land from the Revolutionary War, it was used for a sawmill. The Stone Bridge and Caves became an important Adirondack pathway and were developed as a tourist attraction in the 1950s. Stories are still told today of Portuguese explorers marking on the rocks in the 16th century and Sir John Johnson burying his family treasures on the site.

The Adirondack lakes that have roadways encircling them make good bikeways for bike races. When bikes with shifting gears for changing speeds came into use, races became popular and became part of the annual celebrations in the Adirondack settlements. The race shown here was held in 1956 during the annual Old Home Day celebration at Wells. The race was held around Lake Algonquin. Today some of the Adirondack highways have marked bike pathways along the roadsides for bicyclists.

One bicyclist stands out in Adirondack bikeway history. He was the cycling optimist William Wangenstein of Wells. He not only cycled throughout the Adirondacks, but he made long trips to Michigan, Nevada, Colorado, Tennessee, Kansas, and other states and toured Canada, visiting Quebec City. He also authored *The Cycling Optimist*, promoting bicycling for good health and physical fitness.

An Adirondack Park visitor interpretive center is found along the Adirondack Trail Byway near Paul Smiths. Two visitor centers, the other near Newcomb, were opened by New York State to provide information on Adirondack life. Interpretative trails and naturalist-led programs and exhibits on Adirondack ecology are ongoing. The centers offer lectures and presentations on nature, history, and arts of the Adirondacks.

In days gone by, along the Central Adirondack Byway, Route 28, stood an old log fort. It was the Old Trading Post Restaurant, a popular stopping-off place for those touring the Adirondacks. Owned by the Teich brothers at Eagle Bay, it offered legal beverages and dancing. The post was decorated with mounted animals and also exhibited live Adirondack animals. Horses could be tied to the hitching post in front of the building. This humorous card is entitled *The Tide May Turn*, placing the deer as hunters and men as the hunted.

In the 1940s, Warren County had more dude ranches than any other section in the entire United States. At least 20 ranches were thriving, and it became known as "the Capital of Dude Ranch Country." Places like Thousand Acres, Sun Canyon, Rocky Ridge, and Roaring Brook offered horses, boats, bicycles, swimming, music, rodeos, and sports in an Adirondack setting. The Dude Ranch Byway is a 40-mile loop that starts and ends at Lake George passing through Warrensburg, Stony Creek, and Lake Luzerne, with about a half-dozen ranches still offering the Old West.

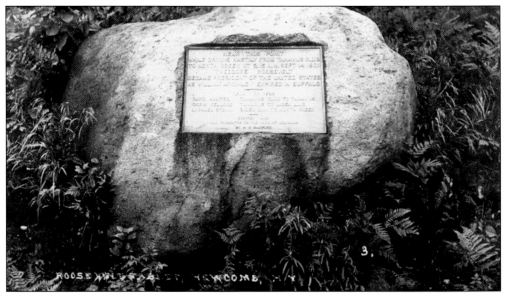

The 40-mile Roosevelt-Marcy Byway connects North Creek to Long Lake, traveling through Minerva and Newcomb on Route 28 north. A historic significance plaque is placed along the highway between those two towns. The plaque reads, "Near this point while driving hastily from Tahawus Club to North Creek at 2:15 a.m. September 14, 1801, Theodore Roosevelt became president of the United States, as William McKinley expired in Buffalo." The plaque has now been taken out of the rock shown here and placed in a stone monument.

Six

Lifeways, My Ways

Regional identities and cultures can disappear if they are not preserved. An oral history project among the Ojibwe Indians, for example, tells of their ongoing efforts to keep their time-honored "lifeways" alive. The Adirondacks have their own lifeways, past and present. Where else are many of the hamlets and settlements named after the lakes: Long Lake, Tupper Lake, Saranac Lake, and Lake Placid? Where else did the indigenous guide boat become the preferred way of transportation? How many communities include those with the second vocation of outdoor guiding? How many places can boast an Adirondack dialect? What other region can match the volumes of literature and lore that have been produced for more than two centuries in the Adirondacks?

The Adirondack culture evolved over the years. The explorers, hunters, anglers, and trappers followed the Native Americans. Later the lumbermen and tanners arrived. Then the wealthy found the Adirondacks and built their estates and hired the local settlers to maintain them. Tourists and campers came too, and some of them stayed and developed strong family communities. All merged their cultures into an Adirondack lifeway that is permanent and seasonal, employed and retired, having local and outside livelihoods, and all sharing a reverence for the mountainous wilderness.

Those who love the Adirondacks have their "my ways"—some favorite hunting ground or secret fishing hole or special rock. In whatever way they have enjoyed the Adirondacks, they have enriched the region by being there.

An important component of the Adirondack lifeway is building a love of the Adirondack forested mountains and remote lakes in the children. Most Adirondack pathways can be hiked and climbed by even the youngest, and some have made the treks riding in an Adirondack pack basket. Once children are exposed to the breathless view from a mountain ledge, they want to do it again and again. The "ocean" of Adirondacks shown here is viewed on the hike up Chimney Mountain.

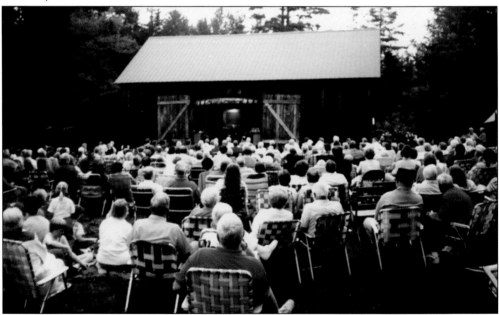

Singing and storytelling have been a part of the Adirondack lifeway since the influx of the loggers and the evolving of the Adirondack guide. They blossomed around the lumber camps and campfires. Songs and stories came from other places, and some grew out of the daily life in the mountains. Wherever festivals are held, large numbers show up to hear, once again, those old Adirondack tales and songs that speak of yesteryear in the Adirondacks.

The Adirondack Mountain region provided the ideal outdoor setting for children's camps, and there is a long history of providing camping experiences for the lifeways of generations of young people. Private camps, church camps, 4-H camps, and scout camps are scattered throughout the forested mountains. Woodworth Lake Scout Reservation opened in the southern Adirondacks in 1950, enjoyed 25 years of successful camping seasons, and then, much like many of the other camps today, downsized and merged and is no longer operating a regular summer camping program.

Scout troops and other outdoor groups have found camping in the Adirondacks to be a fun part of the Adirondack lifeway. Sleeping on the ground in a tent, sitting around a campfire telling stories and cooking marshmallows, and swimming in a cool Adirondack lake have been part of growing up in the Adirondacks. The Adirondack Forest Preserve has traditionally offered unlimited opportunities for camping in the out-of-doors.

Hiking became a part of the lifeways of those who loved the out-of-doors and the Adirondacks. The group shown here climbing the hogsback up Bald Mountain near the Fulton Chain are wearing their Sunday-best. The men are in suits, and the woman has on her long skirt and fancy blouse. They were often referred to as the "city folk" or "summer people."

Living in the Adirondack wilds often resulted in a visit from one of the wild creatures of the forest. Self-sufficiency was the rule of the day for Adirondack settlers; much of what they had came from their own labors. Cutting shingles with a froe and mallet for the roof, dragging native stones for the foundation, and often sawing their own lumber provided the home for the family.

Croquet, a lawn game played with mallets and wooden balls, enjoyed widespread popularity in the Adirondack lifeways. The wealthy folks at Adirondack Great Camp Sagamore enjoyed the game with owner Margaret (Vanderbilt) Emerson. She became a national champion and enjoyed beating her guests at the game. Many of the great camps, such as the Ausable Club, had special lawns groomed for croquet. Birthday parties, shown here, featured a good game of croquet.

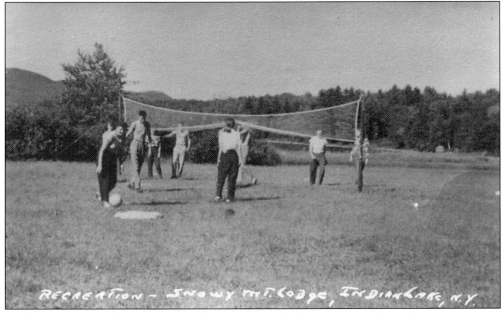

As the American public gained more leisure time with shorter workweeks and longer vacations, organized sports became popular. Golf, croquet, baseball, volley ball, and action games such as hide and seek filled many hours for those who welcomed the fun and exercise. Here a group of vacationers are enjoying a game of volleyball at Snowy Mountain Lodge at Indian Lake. Sports gained a strong foothold in the lifeways of our citizens.

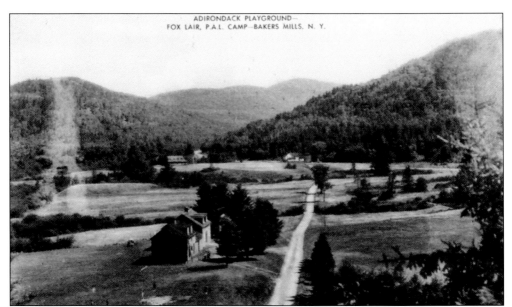

The uses of the Fox Lair property on Route 8 near Bakers Mills has a history somewhat typical of the Adirondack lifeway. It started out as a choice wilderness with some flatland on the river. Once logged off, the Hudnuts found the property and built their wealthy estate. The next owners, the New York City Police, built a police athletic league summer camp. When they closed, New York State took the property and returned it to the wilderness, where it now serves as a primitive campsite.

Ice fishing is part of the lifeway of Adirondack residents and sports. Fishing shanties, pulled out on the Adirondack lakes, provide shelter for those fishing through a hole in the ice. During the Great Depression, many Adirondack families got through the tough winter by catching fish to feed their families. On good lakes, the shanties create a small village on the ice where friendships are formed and winter "cabin fever" fades away.

Hunting camps for seasonal use came in all shapes and sizes in the Adirondack forests, and they became part of a great tradition. They ranged from a simple wall tent to more elaborate log buildings. Most were built of available materials without a big expenditure of money. The camp here has tarpaper on it, a single stove pipe for smoke, and log walls insulated with sphagnum moss.

Hunting was a major part of the lifeway of the Adirondacks from its first days of human intrusion. The vocation of guiding evolved, and "outsiders" paid the locals to set up hunting camps and to guide them in the woods. The wall tent, shown here, tells the story. The little stove with its protruding pipe kept the hunters warm and dried their wet hunting clothes hanging along the wall and their boots. The Adirondack pack basket, the workhorse of the mountains, carried the food and gear.

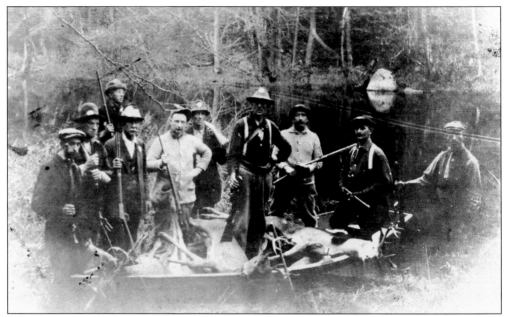

Early Adirondack settlers were forced to live off the woods when cold climate and rocky soils made farming difficult. Hunting the game of the forest became a major part of their lifeways, and the tradition was passed down from father to son, and an occasional daughter. Food for the family and clothes for their backs, along with some cash money for selling furs and guiding, resulted from the successful hunts.

Parades were held on Old Home Days, Fourth of July celebrations, centennials, and other occasions. Local businessmen and groups constructed the floats, and individuals decorated their automobiles and bicycles. This new 1931 Ford and bicycle were spruced up for the Mayfield Bannertown parade. Writing about his hometown parade in Mayfield, the Reverend John E. Thompson observed, "It is not the parade, the fireworks, the rides, the dancing, or the food that makes it successful, it is the home folks!"

Attending band concerts was part of life in the Adirondacks. Most towns had bandstands and a community band. The Saturday night concerts brought community members together. Patriotic and popular songs of the day were performed. This Mayfield band includes Willis Warner on the trombone, Earl Day on the trumpet, and George Olson on the tuba.

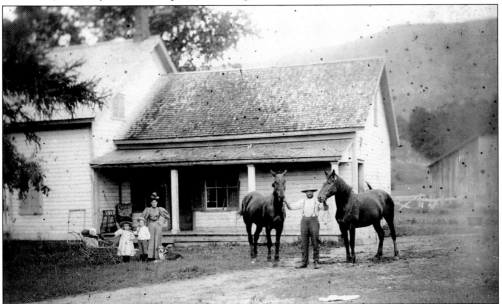

Farm families needed a good team of horses. The team transported the family, plowed the gardens and roadways, and did much of the heavy work required by those who lived close to the land. Horses were in big demand during the winter for the logging and during the hunting season to bring out the deer. This team belonged to the James Hosley farm and was rented by local undertaker George W. Perry to pull the hearse.

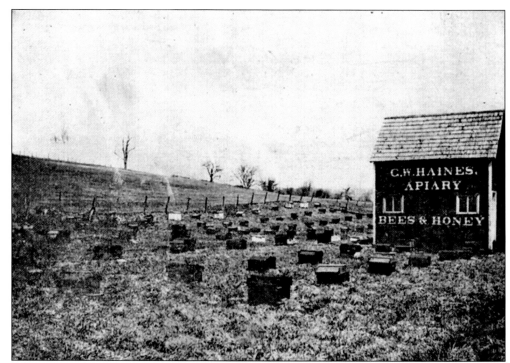

In the 19th and early 20th centuries, settlers searched for wild bee honey in the woodlands. To find it, they would follow two bees making a beeline for the hive. Eventually they turned to beekeeping, as it was easier to catch the swarms and put them in bee boxes where the honey could be extracted each year. During the winter, the bees were kept warm in outbuildings or the cellar.

Riding a horse through the wooded mountains was a choice pastime. Many families had a pony as well as workhorses. Caring for a horse taught responsibility and was part of the children's upbringing.

The old high school at Elizabethtown is now the Adirondack Center Museum. The museum, which is operated by the Essex County Historical Society, has displays on Adirondack mining, farming, trapping, and logging. It also has a fire tower open to all.

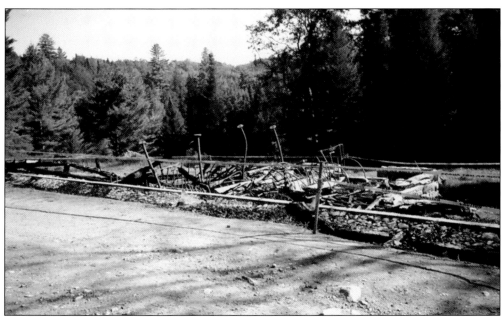

A certain lifeway developed at the great camps. Most had a farm complex with assorted animals, gardens, and dairies to supply the fresh produce and dairy products for the wealthy camp owners. Santanoni had a model farm with large barns. (See *The Adirondacks 1931–1990*, by Donald R. Williams, page 42.) Today the barn complex has been reduced to charred rubble from a disastrous fire in 2005.

The ghost town of Adirondac, once the mining town for the McIntyre Iron Works, now belongs to the people of New York State. Founded in 1840, it is badly in need of restoration. Several buildings remain at the site, and studies are under way to secure them for interpretation and education. Life in an Adirondack mining town had its own ways, and the Adirondac story needs to be told.

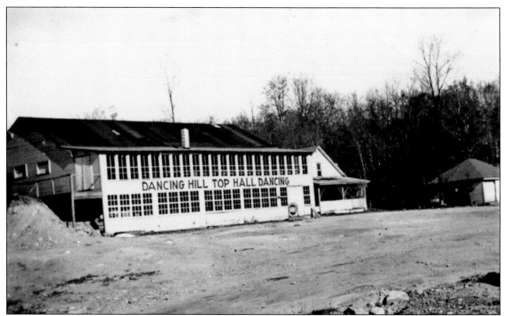

Dance halls were found throughout the Adirondack region during the 1920s and beyond. They were part of the social lifeway of visitors and settlers alike. The Hill Top Dance Hall at Caroga Lake was a popular place for square dancing. It was built and operated in the late 1920s by Julius Rieth, who lived in the little house next door. George Hunt later operated the dance hall and restaurant until it was destroyed by fire in the 1940s.

"My ways" in the Adirondacks is doing what has been done since the first human intrusion into the region; it is unique to those who do it. It can be enjoying a campfire with family and friends, hiking to a waterfall, attending summer camp, sleeping in a lean-to, listening for the shuffling of a wild animal in the woods, enjoying a vista from a mountaintop, lounging on the shore of a sparkling lake or fast-running stream, rowing a guide boat across a peaceful waterway, or bushwhacking through the forest. Most of all, it is finding that health-giving feature of the mountains, lakes, and woodlands that offers a release from the stress and strain of today's world. The author's favorite memories take him back to Auger Falls, Jimmy Creek, Twin Valleys, scout camp, Lake Algonquin, the Northville–Lake Placid Trail, Giffords Valley, Graves Mountain, Chimney Mountain, Kane Mountain Tower, Pine Orchard, and the New York State campsites.

Discover Thousands of Local History Books Featuring Millions of Vintage Images

Arcadia Publishing, the leading local history publisher in the United States, is committed to making history accessible and meaningful through publishing books that celebrate and preserve the heritage of America's people and places.

Find more books like this at
www.arcadiapublishing.com

Search for your hometown history, your old stomping grounds, and even your favorite sports team.

Consistent with our mission to preserve history on a local level, this book was printed in South Carolina on American-made paper and manufactured entirely in the United States. Products carrying the accredited Forest Stewardship Council (FSC) label are printed on 100 percent FSC-certified paper.